IMAGES
of America
ALASKA YUKON
PACIFIC EXPOSITION

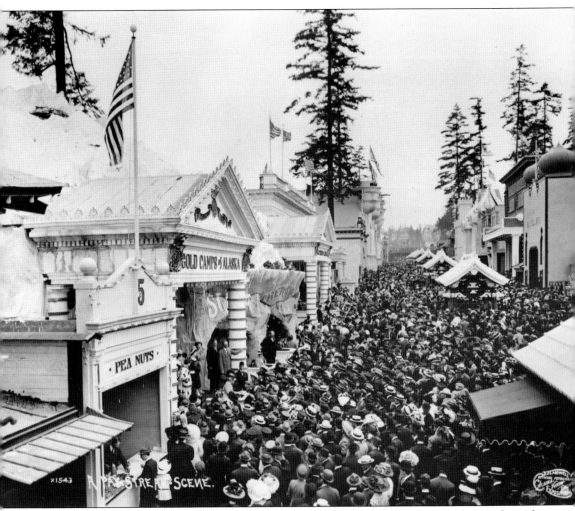

Throngs of visitors take in the sights at the Pay Streak. The diversity of the exhibits along the amusement arcade is seen here with the Gold Camps of Alaska display, Asian pavilions down the middle of the mall, and the Oriental Village and the Streets of Cairo's Middle Eastern turrets looming over the crowds. (Nowell x1543.)

ON THE COVER: This official AYPE photograph shows an aerial view looking towards a painted in Mount Rainier. Taken from the vantage point from the top of the U.S. Government Building, the photograph takes in the Court of Honor, the Cascades Waterfalls, and Geyser Basin. Today this view on the University of Washington campus is called Rainier Vista. (Nowell x1040a.)

IMAGES
of America

ALASKA YUKON PACIFIC EXPOSITION

Shauna O'Reilly and Brennan O'Reilly

ARCADIA
PUBLISHING

Published by Arcadia Publishing
Charleston SC, Chicago IL, Portsmouth NH, San Francisco CA

Printed in the United States of America

Library of Congress Control Number: 2008940092

For all general information contact Arcadia Publishing at:
Telephone 843-853-2070
Fax 843-853-0044
E-mail sales@arcadiapublishing.com
For customer service and orders:
Toll-Free 1-888-313-2665

Visit us on the Internet at www.arcadiapublishing.com

We dedicate this book to our ever-expanding family.

CONTENTS

ACKNOWLEDGMENTS

We would like to express our deep gratitude to all those who made this book possible.

First, we would like to thank Janet Ness from the Puget Sound Regional Archives for introducing us to the endlessly fascinating subject of the Alaska Yukon Pacific Exposition.

Thank you to Nicolette Bromberg, Kris Kinsey, Carla Rickerson, and everyone at the University of Washington Special Collections Library who have worked so diligently to help us with our photographs.

Nancy Hines and all the staff at University of Washington Classroom Support Services worked tirelessly on developing our prints, and we can't thank them enough.

Our gratitude goes out to Carolyn Marr and all of the library staff at the Museum of History and Industry who showed us an amazing amount of support.

Thank you to HistoryLink for informing and inspiring us during the writing process.

And of course we would like to give our thanks to all of the good folks at Arcadia Publishing, without whom this book would not exist. A special thank you to Devon Weston for helping us start the writing process and to our wonderful editor Sarah Higginbotham, who has been instrumental in getting this work published and has helped guide us through this process seamlessly.

And last, but certainly not least, we would love to thank our dear friends and family for their support, particularly our parents, Bill and Janette Dean and Wendy O'Reilly. We love you!

Unless otherwise noted, all images appear courtesy of the University of Washington Libraries, Special Collections. The specific negative number is cited in each caption.

INTRODUCTION

On Tuesday, June 1, 1909, at 8:30 a.m., over 80,000 attendees waited for the gates to open for Washington State's first World's Fair, the Alaska Yukon Pacific Exposition (AYPE). Pressing a telegraph key encrusted in Alaskan Gold, President Taft wired his congratulatory message from the nation's capital. Taft praised the people of the Northwest for holding an exposition designed to celebrate Alaska's wealth of resources and development of trade with Pacific Rim nations. Taft's laudatory wire triggered much fanfare, including the unfurling of a giant U.S. flag, smaller flags, starting of machinery, ringing of bells, Japanese fireworks, and the banging of a massive gong five times. Additionally, ships in the harbor miles away blasted their tributes. Fairgoers were enthralled and commented that the massive entry doors at the main gate opened as if they were automatic.

The World's Fair began as the thought of Godfrey Chealander in June 1905 while serving as the U.S. government commissioner of Alaska for the Lewis and Clark Centennial Exposition. Chealander worried that there was not enough time, focus, and resources to prepare a sufficient exhibit on Alaska and its untold wealth. While working on the exhibit for the Lewis and Clark Centennial Exposition in rival city Portland, Oregon, Chealander paid a visit to Seattle and imagined an exposition of its own to highlight Alaska. A letter was sent to John E. Chilberg, president of the Alaska Club located in Seattle, proposing an Alaskan fair held in Seattle, Alaska's gateway, which would rival the Lewis and Clark Centennial Exposition. Originally the exposition was to cost $100,000 and be paid for by Seattle-area businessmen. Seattle newspapers caught wind of the idea, and many businessmen jumped at the opportunity. The idea for the exposition grew and was discussed in every Alaska Brotherhood meeting. Eventually the concept was extended to include the Yukon Territory and territories that bordered the Pacific Ocean, and the budget of $100,000 was discarded. Producing an exposition of this proposed size required support and participation from many civic leaders. Chilberg formed the Alaska Yukon Pacific Exposition Company in May 1906.

During the early 20th century, the University of Washington experienced tremendous growth challenges. While the student body was ever increasing, the three buildings to house and teach the student population could not accommodate the growth. In 1905, the legislature failed to approve funds for the growing campus, forcing University of Washington president Thomas Franklin Kane to approach the board of regents for funding of temporary structures. While transitory buildings served short-term needs, the student numbers continued to overwhelm the campus. Some classes were divided into sections and met in building attics and basements. Other classes were forced to meet in ad-hoc class space resulting in ineffective learning. President Kane complained about the uneconomic use of educators but was challenged in finding solutions. A June 16, 1906, meeting between a committee of prominent Seattle residents and the board of regents promised Kane much needed relief. On this date, Seattle citizens approached the board of regents with the idea of hosting a large promotional exposition for a couple of months

on the University of Washington campus. These businessmen saw the campus as having many advantages, including the size of land and particularly the incredible views of lakes and mountains. The improvements to the university included the construction of many permanent buildings that would be constructed to university specifications and could be used for education after the exposition concluded. However, the board of regents still needed convincing since at the time the campus bordered the city limits and there was little by way of public transportation to the downtown business core. In 1909, only 2,000 cars were registered with the state, thus many depended on use of public transportation.

Edmond Meany, professor of botany and history, served as a trustee, was on the executive committee of the exposition, and was instrumental in passing legislation that moved the territorial university to its present location. Seeing the many potential benefits the exposition could bring to the university, Meany was a large proponent of using the University of Washington campus for the exposition and helped convince the board of regents. After consideration, the board of regents and state legislature granted use of the 355-acre campus to the exposition with the expectation that permanent structures would be built to expand the college campus.

After identifying the physical location of the World's Fair, the Alaska Yukon Pacific Exposition Company's next feat was to procure the over $10 million in funding required for the fair. Preliminary funds were raised through a capital stock offering of which residents demonstrated true Seattle spirit by purchasing $650,000 shares within 12 hours. Next the state legislature appropriated $1 million for exposition construction with $600,000 of the approved funds made available to the board of regents for construction of three permanent buildings: the auditorium, a laboratory for chemistry and pharmacy, and a building for the College of Engineering. The federal government, recognizing the value of the exposition, contributed $600,000 in funding. Potential exhibitors consisting of states, cities, counties, local banks and individuals, societies, and foreign governments filled in the remaining balance of millions.

The Olmsted Brothers company, of Brookline, Massachusetts, was originally hired in 1903 by the board of regents to identify grounds improvements for the University of Washington to better align the campus with the proposed park system for the City of Seattle. While the original plan was never implemented, the Olmsted Brothers company continued its existing partnership with the City of Seattle by designing a grand park system. After deciding to host the AYPE on the campus grounds, the board of regents engaged Olmsted Brothers to design approximately 250 acres of the lower campus into the exposition fairgrounds.

What took place over the two-year construction was amazing. The Olmsted Brothers company transformed the once dense, old-growth forested grounds into an open slope filled with elaborate gardens, pools, walkways, and fountains. The grounds were planned around a long pool with cascading waterfalls and the focal point of Mount Rainier. Circling the long pool were statues representing the North, such as elk, bear, timber wolf, and cougar. At the head of the Cascades Waterfalls was a 90-foot-tall towering sculptural monument with three seated female figures at the base symbolizing the North, South Seas, and Orient. Over one million plants, grown in greenhouses on the new grounds, were used in the ground decorations. One hundred acres of the campus had been turned into formal gardens with green lawns and filled with rhododendrons, cactus dahlias, and pansies. The beauty of the formal gardens was often compared to the public gardens of Versailles. The gardens lived on past the AYPE, and the Olmsted Brothers company plan is still visible in the layout of the campus today. Though many buildings now replace the once beautiful sunken gardens, the overall layout is still very much intact.

Transforming the dense, thicketed landscape required blasting, which at times caused the president concern for the existing buildings. The transformation was very costly, with close to $381,000 expended on just the grading and landscaping alone, which was almost as much as what had been spent on constructing the new permanent campus buildings. Layout of the grounds was a marked departure from the typical Seattle street system. Instead of constructing walkways and streets on right angles, Olmsted Brothers created sweeping, curved walkways with incredible vista views of Lake Washington, Lake Union, and Mount Rainier. The Olmsted Brothers exposition

layout inspired many of Seattle's new neighborhoods at that time, focusing on humane living environments with suburban streets filled with sweeping drives and cul-de-sacs.

John Galen Howard's San Francisco firm Howard and Galloway was the supervising architectural company for the Alaska Yukon Pacific Exposition. Howard's firm designed the buildings around the central focus of the fair in the French-Renaissance style. Other buildings in the periphery of the grounds were designed in a combination of French Renaissance, Spanish mission, Japanese, Chinese, Colonial, and Roman classic architectures. Due to the palatial buildings, ornate style of architecture, and ivory-colored exteriors, the exposition became known as the "Ivory City." Building sponsors chose the architecture for their respective buildings, which resulted in a variety of different styles of architecture. Many of the buildings contained pergolas covered in climbing roses, clematis, and woodbine to enhance the architectural beauty. The layout of the buildings was also different from previous World's Fairs. The buildings were in close proximity, requiring patrons just a short step from building to building.

On June 1, 1907, before 15,000 excited Seattleites, the first shovel full of earth was turned, breaking ground on the new exposition fairgrounds. The ground-breaking ceremony took place in the natural amphitheater located on the northeast side of the exposition grounds in what is now the present-day Padelford Hall and parking garage. The fair was originally proposed to take place in 1907 to commemorate the 10-year anniversary of the Klondike gold rush, but due to the Jamestown, Virginia, exposition being held that same summer, the fair's organizers decided to reschedule the exposition. The year 1909 was chosen since 1908 was the year of the presidential election. The additional two years gained by postponing the exposition allowed for greater planning and fund-raising. Construction of the fairgrounds spanned the time from the ground-breaking ceremony almost up to the opening of the fair in 1909. By the beginning of 1909, acres of gardens and grounds had been completed, miles of thoroughfares paved, and eight of the larger buildings completed. Preparing for the exposition required building a small city's worth of sewer, electrical, and road and rail infrastructure. Transforming the 250 acres into a fairyland of exhibits in the span of two years was an incredible feat. There was concern that the fair and the Brooklyn District would not be ready in time for the opening. In April 1909, a total of 2,100 workers put the finishing touches on the buildings and grounds. The fairgrounds were completed on schedule and ready for opening day.

Throughout the summer of 1909, excitement pulsed through the city as Seattle filled with eager fairgoers. Seattleites found their way to the fair in droves, soaking in the new experiences, technology innovations, and cultural oddities that the exposition had to offer. In one day, a fairgoer could take in a cattle show, a ride in a hot air balloon, watch a reenactment of the Battle of Gettysburg, witness the charms of an exotic dancer, see the workings of the U.S. Mint, and enjoy the countless exhibits that educated as well as entertained, capping it all off with an evening of fireworks. However, one day was usually not sufficient, and many fairgoers came back repeatedly to take in the sights. When the fair wasn't enough, people could also take organized side trips to Snoqualmie Falls, Hood Canal, Tacoma, and surrounding areas, or they could spend the day in downtown Seattle shopping and sightseeing.

The exposition opened its gates from June 1 to October 16, 1907. When the fair finally closed, over 3.7 million visitors had seen the many sights offered by the exposition. Visitors came from all over the world to see exhibits from Canada's Yukon, the U.S. government, different American states, and local counties and cities. After concluding the exposition, many of the AYPE buildings needed repairs to be used by the university as classrooms. Equipping the permanent buildings alone cost $88,617 in repairs and remodeling. However, the permanent buildings served the university for a half century or longer. The transitory AYPE buildings had been built with temporary edifices of plaster versus brick and steel and were not originally intended for use as class space, but due to space constraints the temporary buildings were used long after the fair concluded. The law school and German department occupied the Oregon Building, while the University Library occupied the Washington State Building. The Educational Building serviced the departments of education and journalism, and the president adapted the New York State Building into a residence.

While the space issue was alleviated for a short time, the foundations crumbled within a couple of years, plaster walls disintegrated, and the sewer connections failed completely for a number of the temporary buildings. Architects and contractors were consulted in 1914, and the outlook was grim. They insisted on abandoning several of the buildings and consequently the temporary structures were razed in the years to follow. Of all the buildings constructed for the exposition, five remain as of 2009: Architecture Hall (Fine Arts building for AYPE), Cunningham Hall (Women's State Building for AYPE), Power Plant (Power House for AYPE), Physical Plant Office (Michigan State Building for AYPE), and the Mechanical Engineering Annex (the Foundry for AYPE). The Olmsted grounds layout has remained largely unchanged while the university continued to grow. Geyser Basin, now known as Drumheller Fountain or Frosh Pond, and the view of Mount Rainier were both preserved, and the beautiful sunken gardens are now vast lawns dotted with buildings.

The lasting legacy of the AYPE is reflected in the University of Washington campus today. While the goals of expanded trade, influx of new residents, and new buildings to serve the ever-growing university student body were not yet fully realized, the AYPE was considered by many to be very successful. The Alaska Yukon Pacific Exposition received profits from the exposition in the amount of $63,000, which was donated to the Anti-Tuberculosis League and the Seamen's Institute. Seattle saw millions of visitors over the span of a couple of months. The Alaska Yukon Pacific Exposition was a major milestone for the small city. Seattle was no longer to be thought of as pioneer town, but as truly the thriving Emerald City.

One

ORIGINS

What began as the dream of Godfrey Chealander and John E. Chilberg to extol the riches, wonder, and beauty of Alaska resulted in an almost four month World's Fair that showcased Alaska, the Yukon, Pacific Rim nations, and the Orient and entertained close to four million fairgoers. When the Alaska Yukon Pacific Exposition gates opened on June 1, 1909, patrons were greeted by a sprawling 250-acre wonderland of ornate ivory-colored buildings; living landscapes of beautiful sweeping lawns; millions of dahlias, pansies, and roses; and the most incredible views of freshwater lakes and Mount Rainier. The AYPE evolved into an event much grander than originally anticipated.

Over $10 million and two years were spent in constructing the largest exposition and first World's Fair in the Northwest. Seattleites were ecstatic to sponsor a fair in their small city. Proof of their excitement was evident in the fact that they raised $650,000 in one day to sponsor the AYPE by purchasing stock. This was the largest sum of money ever raised in one day by a city for any purpose. The most appropriate place to hold such a fair was the largely virgin forested area of the new University of Washington campus. Twenty minutes from the center of town with little by way of buildings, the university was the perfect candidate to hold the exposition. It was in large need of space for the student body, and the mix of permanent and temporary buildings that would be left over from the exposition seemed to fulfill the demand.

While highlighting the virtues of Alaska, the AYPE educated and entertained attendees with palatial buildings, which housed exhibitions from all over the United States and countries bordering the Pacific as well as Atlantic Oceans. Visitors came to partake in the grandeur of the event, be mesmerized by the oddities of the Pay Streak, and educated by the exhibitions. They left with memories of one of the most beautiful expositions the world had ever seen.

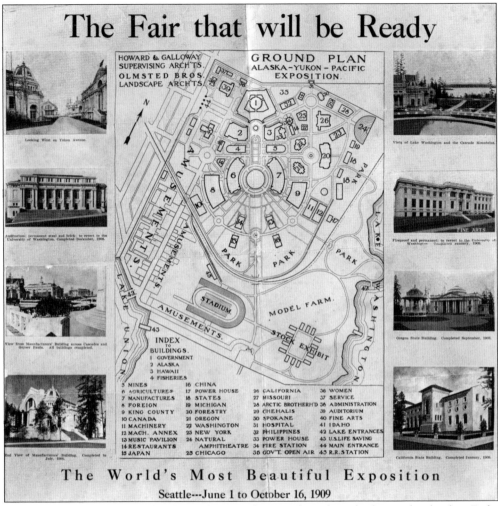

The Fair that will be Ready

HOWARD & GALLOWAY SUPERVISING ARCH'TS.
OLMSTED BROS. LANDSCAPE ARCH'TS.

GROUND PLAN
ALASKA-YUKON-PACIFIC EXPOSITION.

INDEX TO BUILDINGS.

1 GOVERNMENT	16 CHINA	26 CALIFORNIA	36 WOMEN
2 ALASKA	17 POWER HOUSE	27 MISSOURI	37 SERVICE
3 HAWAII	18 STATES	28 ARCTIC BROTHERH'D	38 ADMINISTRATION
4 FISHERIES	19 MICHIGAN	29 CHEHALIS	39 AUDITORIUM
5 MINES	20 FORESTRY	30 SPOKANE	40 FINE ARTS
6 AGRICULTURES	21 OREGON	31 HOSPITAL	41 IDAHO
7 MANUFACTURES	22 WASHINGTON	32 PHILIPPINES	42 LAKE ENTRANCES
8 FOREIGN	23 NEW YORK	33 POWER HOUSE	43 U.S.LIFE SAVING
9 KING COUNTY	24 NATURAL	34 FIRE STATION	44 MAIN ENTRANCE
10 CANADA	AMPHITHEATRE	35 GOV'T. OPEN AIR	45 R.R. STATION
11 MACHINERY	25 CHICAGO		
12 MACH. ANNEX			
13 MUSIC PAVILION			
14 RESTAURANTS			
15 JAPAN			

Looking West on Yukon Avenue.

Auditorium: permanent steel and brick; to revert to the University of Washington. Completed December, 1908.

View from Manufacturers' Building across Cascades and Geyser Basin. All buildings completed.

End View of Manufacturers' Building. Completed in July, 1908.

Vista of Lake Washington and the Cascade Mountains.

FINE ARTS
Fireproof and permanent; to revert to the University of Washington. Completed January, 1909.

Oregon State Building. Completed September, 1908.

California State Building. Completed January, 1909.

The World's Most Beautiful Exposition
Seattle---June 1 to October 16, 1909

This ground-plan map tantalized Seattleites with a sneak peak at the layout for the fair. Eight photographs of completed buildings and other attractions further whet fairgoers' appetites showing exposition buildings as well as buildings that would revert to the University of Washington after the fair. (Museum of History and Industry 2005.35.03.)

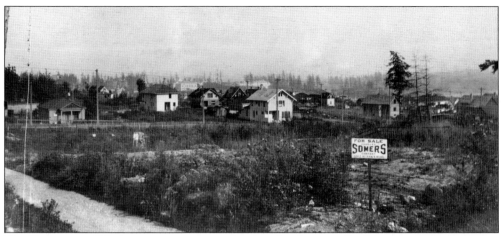

The University of Washington campus was chosen to be the grounds of the exposition. Seen here before construction started, it consisted mostly of forest and residential houses; only a handful of university buildings stood before ground-breaking took place, including Denny Hall, which is still used for classes on the campus today. (UW28076.)

First Assessment *of* 25 Per Cent.

On the Capital Stock **Payable October 2, 1906**

Edmond S Meany *Dr.*

Alaska-Yukon-Pacific Exposition

SEATTLE, U.S.A.

Folio *Number of Shares Subscribed for by You* ___fair___

Par Value of Your Shares $ ___40.00___ *Amount Due* *First Assessment* $10.00

 Amount Due Second Assessment $

 Amount Due Third Assessment $

 Amount Due Fourth Assessment $

Amount Paid $10.00 *Total* $

The exposition was partially paid for by the state legislature, so that the area could be used as the University of Washington campus after the fair. Another portion of the exposition was paid for in a single day, October 2, 1906, by the sale of stock shares to the people of Seattle. This $10 stock certificate belonged to University of Washington professor Edmond Meany and helped to raise $650,000. (UW28133.)

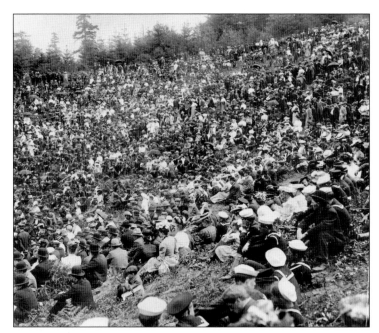

Over 15,000 people attended the AYPE ground-breaking ceremony on June 1, 1907, seen here in one section of a two-part panoramic photograph. The crowd became a bit overenthusiastic after the ceremonial shoveling of dirt and rushed the stage, grabbing handfuls of dirt, bunting, flags, and anything else they could get their hands on. (UW26865.)

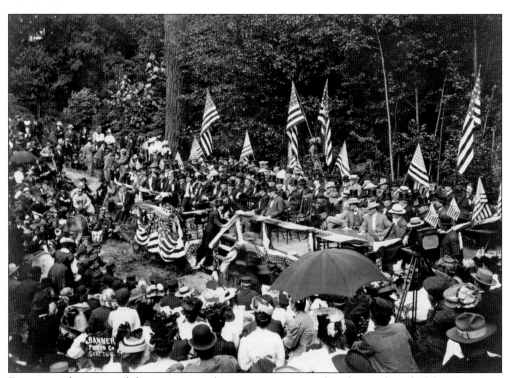

Dignitaries from around the region, seen here on a stage erected in the south end of the University of Washington campus, facilitated the official ground-breaking ceremony. AYPE president John Edward "Ed" Chilberg is in line to give a rousing speech. The flags flying overhead were later used for the duration of the AYPE. (UW28120.)

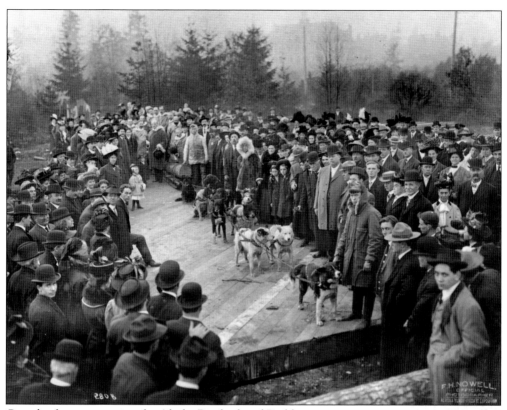

Crowds of spectators view the Alaska Brotherhood Building presentation ceremony on November 10, 1908. The first log of the building was carried by a team of sled dogs to the construction site. The building was presented to the AYPE and the University of Washington by the Alaska Brotherhood fraternal organization. (UW28046.)

Members of the lumbermen's fraternal organization known as the Hoo Hoo oversaw the ground-breaking ceremony for the Hoo Hoo House. The structure was designed by Seattle-based architect Ellsworth Storey in the style of prairie architecture and was unique to the Pacific Northwest. Today the building would have stood right behind the Husky Union Building on the University of Washington campus. (UW28044.)

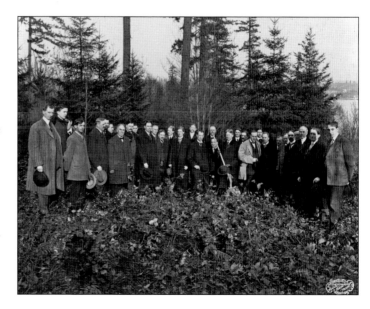

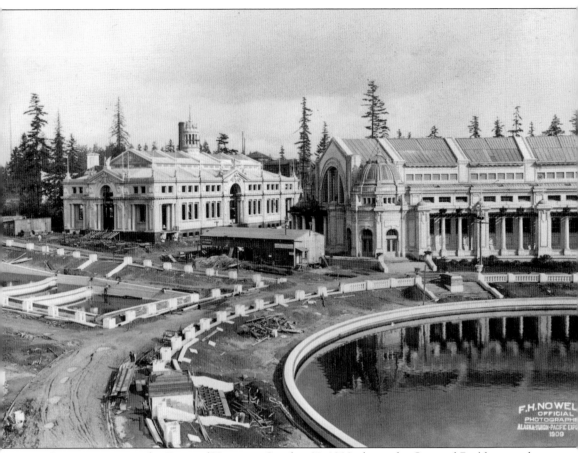

Construction near the Court of Honor on October 21, 1908, shows the Oriental Building on the left and the Manufactures Building on the right with the Geyser Basin, already filled with water, in the foreground. The Cascades Waterfalls, to the left in the photograph, sits unfinished, but the scale can be appreciated when the tiny construction worker is seen standing in the empty fountain. (UW28045.)

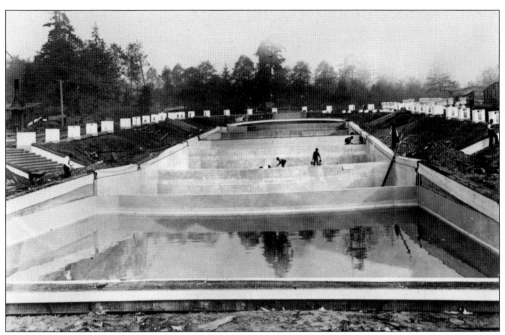

Massachusetts design company the Olmsted Brothers, who also designed Seattle's Park System, was responsible for the look of the AYPE. The signature of the fair was the Cascades Waterfalls, a fountain that ran down Rainier Vista to Geyser Basin, an arcade that framed a view of the majestic Mount Rainier. Construction workers seen here are hard at work finishing the waterfall. (UW11727.)

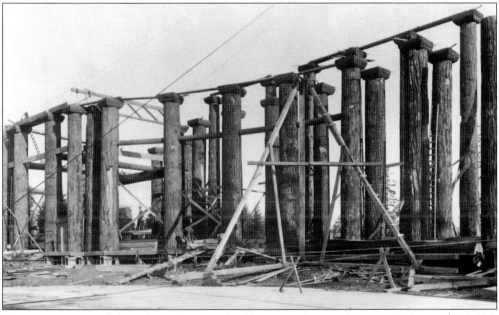

The construction of the massive Forestry Building, seen here in January 1909, cost $300,000. The building used Douglas fir logs shipped in from Snohomish County. The building had 124 columns, bark intact, that were 4.5 feet in diameter and 37 feet high, each weighing a whopping 50,000 pounds. The Forestry Building was razed in 1930 due to dry rot and an infestation of bark beetles. (Nowell x408.)

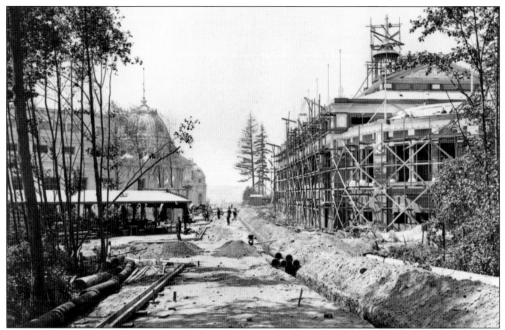

Buildings began springing up during the construction of the AYPE, as seen here looking down Yukon Avenue in August 1908. The Manufactures Building is being constructed on the right and the Oriental Building on the left. Extensive deforestation and regrading were required to allow the necessary building for the exposition. (Nowell x129.)

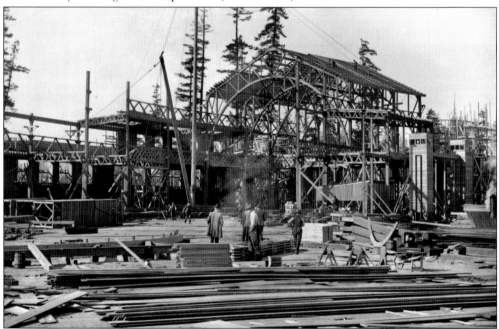

The 60,000-square-foot Agriculture Building is seen here under construction on March 19, 1908. This structure, which was the main exhibit building for Washington counties that did not have their own buildings, was designed as a stark-white beauty with a circular pergola that would highlight its Ionic columns. (UW28043.)

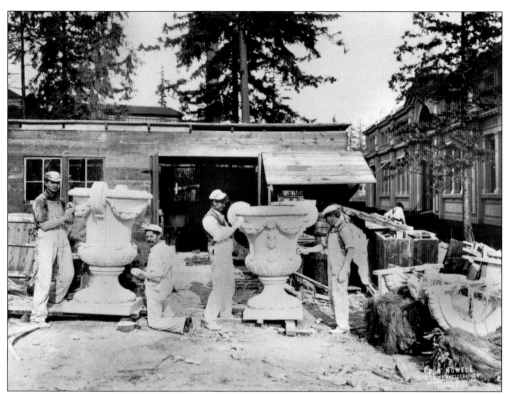

This photograph features a construction crew of plasterers building the iconic flower planters that lined the elaborate sunken gardens and paths that sat below the Geyser Basin. These detailed urns were made in two parts with giant mold castings and then placed together, cleaned, and further refined by these hard-working men. (UW26864.)

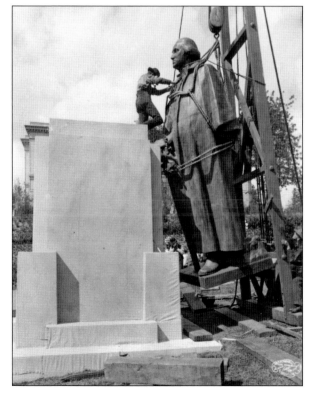

The George Washington statue installation was made possible through fund-raising efforts of the Daughters of the American Revolution (DAR). It was one of the first things guests saw as they walked through the main entrance, and it still stands at the entrance of Red Square on the University of Washington campus where it serves as a well-known landmark for students. (Nowell x1913.)

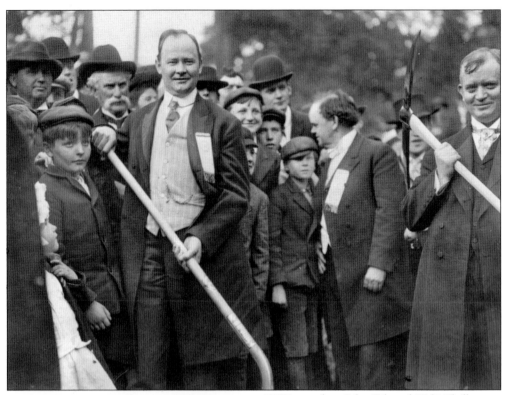

AYPE president John Edward "Ed" Chilberg is shown holding a shovel at the ground-breaking ceremony on June 1, 1907. President Chilberg was a successful Seattle businessman, builder, and realtor who spent two terms as president of the Seattle Chamber of Commerce. He was chosen as president of the AYPE after he helped spearhead the idea of Seattle's first World's Fair. (UW27548.)

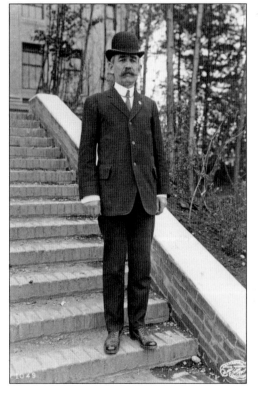

Ira A. Nadeau served as the director general of the AYPE. He was the vice president of the Seattle Chamber of Commerce and was a former general agent of the Great Northern Railway, which contributed a great deal of money to the construction of the exposition. Elected into his AYPE position, Nadeau felt the fair was important in promoting Washington's railways and products. (UW27587.)

Henry E. Dosch was elected to the position of director of exhibits for the AYPE. Born in Germany, he was a colonel in the German army and first came to the United States in 1860. In his busy retirement, Dosch became the official horticulturalist of Oregon and subsequently worked on designing and implementing several World's Fairs throughout the country, including the AYPE. (UW27586.)

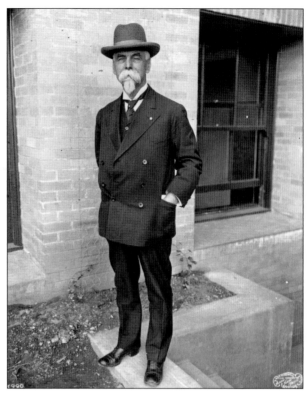

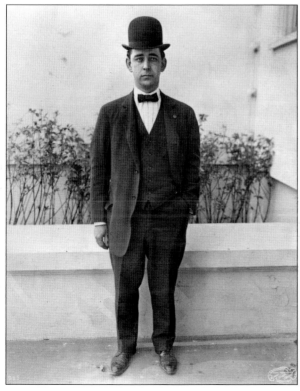

Frank P. Allen Jr. held the position of director of works for the AYPE. He was an architect and engineer who was responsible for much of the structural work of the Lewis and Clark Centennial Exposition in Portland, Oregon, in 1905. Allen went on to design the Panama-California Exposition in San Diego in 1911 and subsequently influenced a great deal of that city's architecture. (UW27584.)

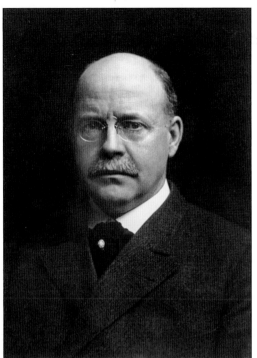

Seattle realtor John H. McGraw served on the executive committee of the AYPE. McGraw was best known for being elected the second governor of Washington State in 1892. In 1897, after his term, he left to join the Alaskan gold rush and returned to Seattle to become a leading businessman. Besides his other political work, McGraw also served as president of the Seattle Chamber of Commerce. (UW3284.)

A. W. Lewis served as the director of concessions for the AYPE and was responsible for attracting the finest in midway amusements for the Pay Streak as well as managing the concessions on a day-to-day basis. Halfway through the AYPE, Lewis resigned to manage an upcoming World's Fair in California and was replaced by E. G. Mattox. (UW28047.)

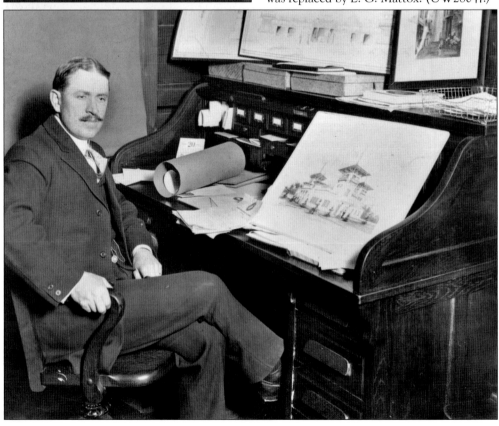

AYPE officials and the Seward family unveil the William H. Seward statue at a special ceremony. Seward was a New York senator and secretary of state and was responsible for the purchase of Alaska from Russia. The AYPE honored Seward because of his deep involvement with relationships between Alaska and the Pacific Northwest. The statue still stands in Seattle's Volunteer Park. (UW18666.)

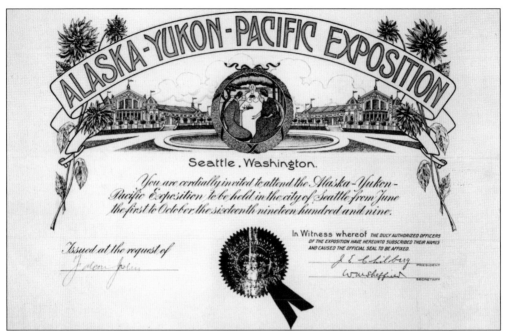

This decorative general invitation to the AYPE sports an embossed gold seal with a printed blue ribbon, and president John E. Chilberg and secretary William Sheffield's signatures. The drawing centers on the official symbol of the AYPE with three women surrounded by the Arctic Circle with clouds and dahlias supporting the banner. (UW28132.)

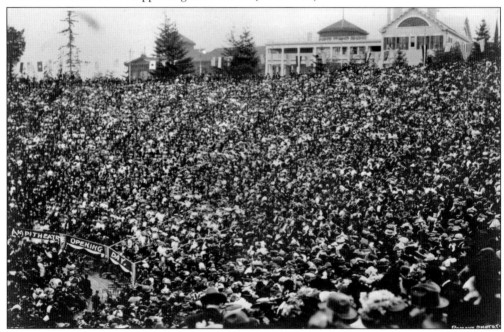

The opening-day ceremonies at the AYPE Amphitheatre were held on June 1, 1909, exactly two years after the ground-breaking ceremonies. The doors opened to the public at 8:30 a.m., and soon more than 80,000 people swarmed the opening-day ceremonies—so many that Seattle declared June 1 a city holiday. (UW28094.)

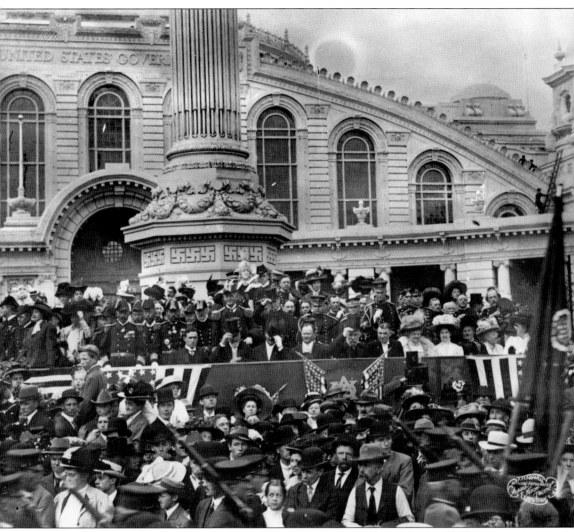

AYPE officials and dignitaries, including prominent AYPE president John E. Chilberg, sit at a podium in front of the U.S. Government Building at the opening-day ceremonies. Members of the Japanese and U.S. Navies are among the luminaries who joined the officials onstage watching as soldiers march past carrying rifles. The embossed swastikas were an ancient Hindu symbol representing good luck and well-being. (UW18667.)

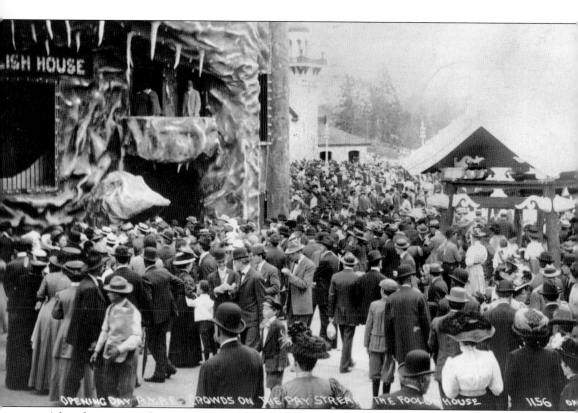

After the opening-day ceremonies, the crowds were ready to unwind on the Pay Streak. Here throngs of people mill about in front of the Foolish House, an amusement that was most certainly like the fun houses one sees now at modern carnivals. Note the gentlemen peering over the balcony of the Foolish House, which was part of the maze of the attraction. (UW28093.)

Two

AROUND SEATTLE

In 1909, Seattle was on the verge of a great boom in population, growth, and prosperity. The population in 1880 was just 3,533, but by 1910 it was 237,194. That is a 6,600-percent increase. This growth was directly attributable to the Klondike gold rush and the huge drawing power of the AYPE, which showcased the livability of the city of Seattle.

The University District was, at the time, called the Brooklyn District and was mostly populated with residences. The forthcoming World's Fair brought a boost to the area with a sudden inundation of storefronts, hotels, and restaurants. The Latona Bridge spanned Lake Union, connecting Eastlake with the University District. Streetcars were a main form of transportation around the neighborhood that hosted the AYPE and provided a 20-minute ride from downtown.

Downtown Seattle, where many of the out-of-town visitors to the fair stayed, saw a huge increase in business, especially at shops like the already well-established department stores Frederick and Nelson and Nordstrom. If shopping for food, local grocery stores sold a loaf of bread for 5¢ and a gallon of milk for 33¢. One could mail a letter for 2¢, buy a new car for $500, or, if planning on staying in Seattle after the fair, a new house for $4,500.

The Denny regrade was part of a project to literally flatten out the hilly Seattle terrain. From 1902 to 1911 there was a massive undertaking of sluicing an entire section of the city into Elliott Bay. Houses and other buildings were either torn down or physically moved to other parts of town. The regrade, having torn apart just north of the downtown corridor, became something of a tourist attraction in itself for fairgoers. Visitors attending the AYPE made side trips to check out the mayhem and perhaps buy a picture postcard of the ruined hillsides to send home.

Seattle was, and still is, an ever-evolving metropolis. Though populations and prices have changed through the years, the pioneering spirit of its people is everlasting.

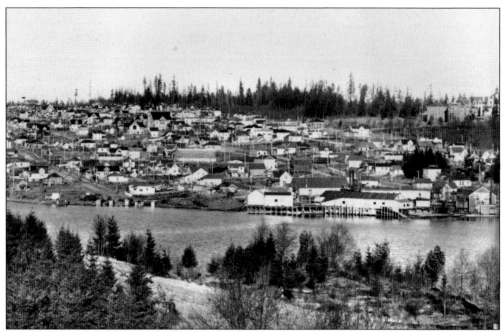

The view above of the University of Washington campus and University District, then called the Brooklyn District, is from north Capitol Hill across Portage Bay in 1907. On the far right of the photograph sits Denny Hall, which was then the Administration Building, and Parrington Hall. The photograph below is a view from farther west, taken in 1906. Denny and Parrington Halls are visible as are a number of small homes. Much of the forested area surrounding the campus was razed for the exposition. The Montlake Bridge, which wasn't built until 1914, would appear off the far right edge of the photograph, finally connecting the University District and Capitol Hill. (UW23076, A. Curtis 03191.)

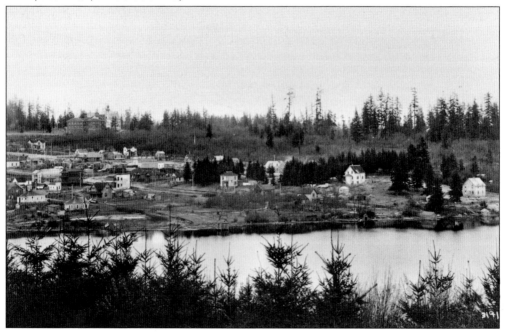

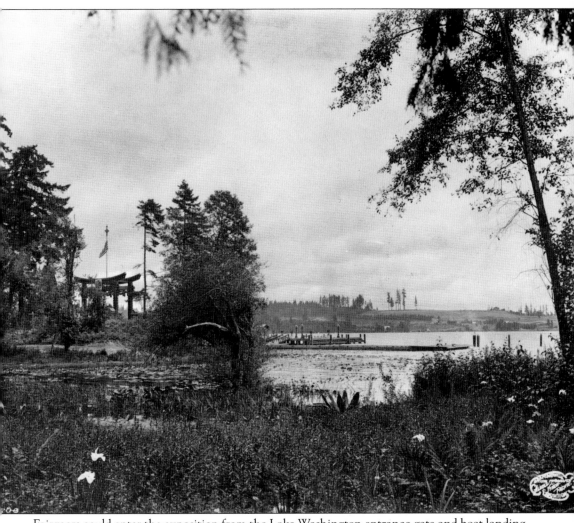

Fairgoers could enter the exposition from the Lake Washington entrance gate and boat landing. This view is looking east from about where the University Boathouse is located today. To get to the fair, visitors would follow a westward path next to a model farm that goes over a rustic train trestle. The deforested hill in the background is the Laurelhurst District of today. (Nowell x2708.)

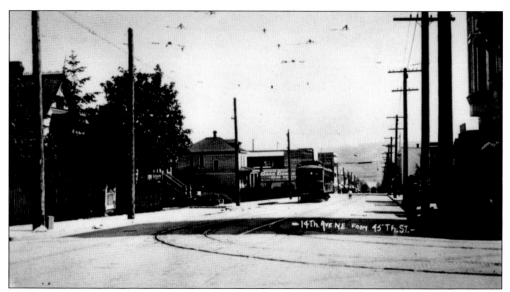

This view of University Way (then Fourteenth Avenue NE) looking south from NE Forty-Fifth Street shows one of the trolleys that traveled to downtown and the Wallingford neighborhood. This area had mostly residential homes at the time but today is a bustling intersection filled with businesses and college students. (Warner 46x.)

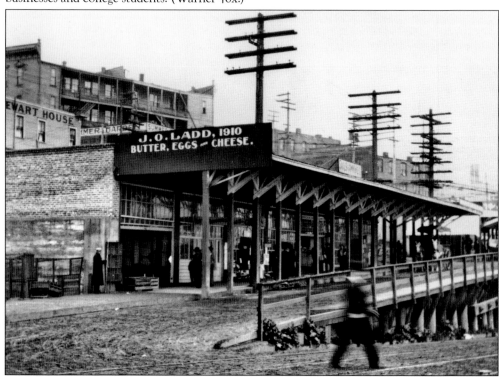

These are typical businesses that visitors and residents of Seattle might have patronized during the time of the AYPE. This view is from Virginia Street and Western Avenue in downtown Seattle on May 19, 1909. Looking northeast from Pike Street and Western Avenue, this photograph shows the Stewart House in the background at 86 Stewart Street and the J. O. Ladd store. (LEE35.)

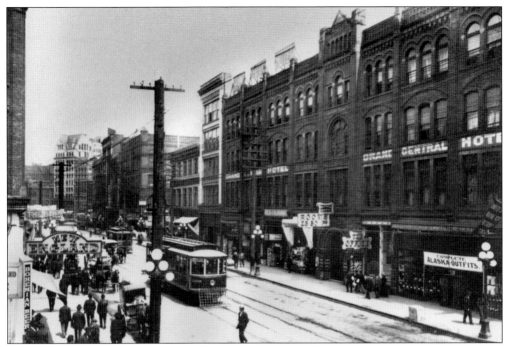

Looking north on First Avenue south from South Main Street, this photograph shows the Grand Central Hotel on the right and the Hotel New England on the left—two examples of places visitors to Seattle stayed during the exposition. Businesses, like the one in the lower right of the photograph, took advantage of the tourism draw of the AYPE by providing "complete Alaska outfits." (A. Curtis 13395.)

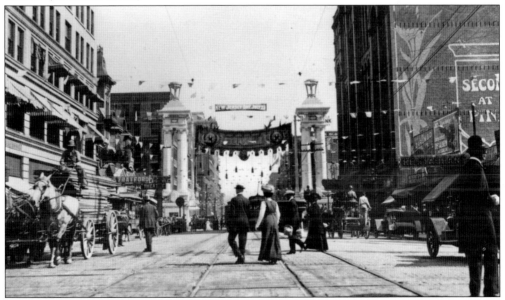

This view from Second Avenue in downtown Seattle shows the Vancouver B.C. Welcome Arch that spanned Marion Street. The arch was a gift built by the City of Vancouver, British Columbia, Canada, for the exposition and welcomed visitors to the Pacific Northwest. Both automobiles and horse-drawn carts were being used for transportation at the time. (UW28105.)

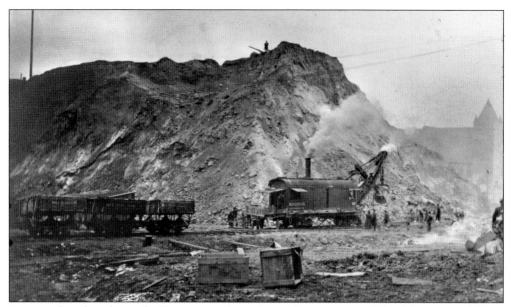

A steam shovel works on the Denny regrade at the southeast corner of Third Avenue and Olive Way. This photograph shows the extent of change the city of Seattle was undergoing during the AYPE. To appreciate the scale of the earth being moved, note the tiny construction worker at the top of the photograph looking down at the mine railway cars. (UW28099.)

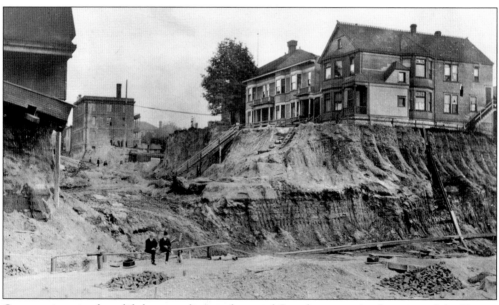

One can imagine how life became disrupted around Seattle as seen in this view of the Denny regrade looking south at Sixth Avenue from Seneca Street; two gentlemen rest on a makeshift sidewalk handrail amid piles of bricks and refuse. The back of the photograph states that the Providence Hospital building can be seen in the distance. (UW28097.)

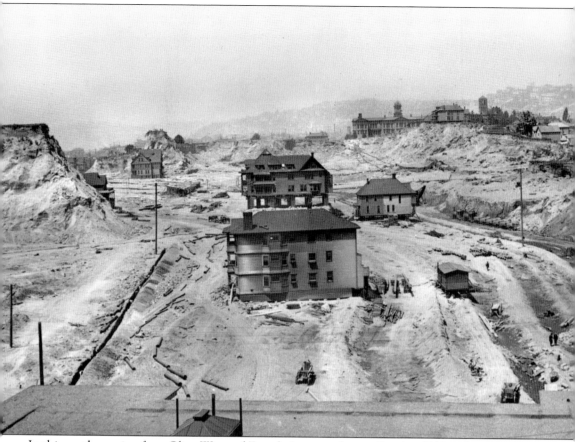

In this northern view from Olive Way and Fourth Avenue taken in October 1909, right after the end of the AYPE, a few lonely houses are still in the process of being moved from the Denny regrade area. The house in the center of the photograph sits on stilts awaiting its fate. (LEE20024.)

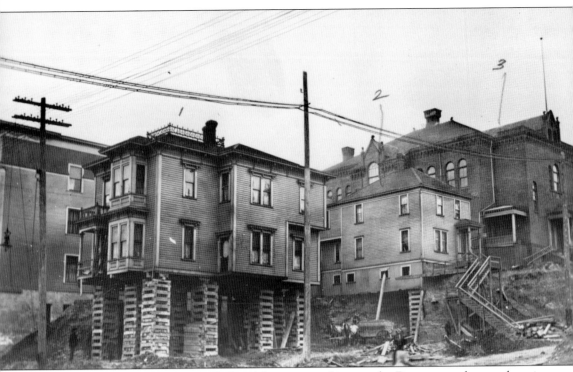

Even AYPE president John E. Chilberg's home was subject to the Denny regrade, seen here in March 1909. His house stands second from the right at the northeast corner of Fifth Avenue and Seneca Street, in between an apartment building hoisted on frighteningly tall stilts and the Presbyterian Church. (UW28098.)

Three

BUILDINGS AND GROUNDS

The fair's organizers could not have found a more beautiful or picturesque setting for the AYPE. With views of Mount Rainier, the Cascade Mountains, and two freshwater lakes on either side of the fairgrounds, the 250 acres were a breathtaking canvas for a World's Fair.

The famed Olmsted brothers, of the Olmsted Brothers company, were brought in to design an elaborate landscape for the fairgrounds. No strangers to Seattle, having designed many of the city's parks, the Olmsted brothers' layout reflected their passion for the City Beautiful movement that was so popular during the first part of the 20th century. Copying the grand old European cities' penchant for broad boulevards, sweeping vistas, and stunning architectural focal points, the movement sought to bring moral and civic virtue by beautifying city spaces.

This movement was strongly evidenced with the main section of the fair, the Court of Honor, in which the U.S. Government Building stood magnificently reigning over its surrounding structures. Ivory-hued, French Renaissance–styled buildings such as the Oriental and Alaska Buildings flanked the Rainier Vista, while the Cascades Waterfalls flowed down to the Geyser Basin below. Beyond the pond, 100 acres of gardens filled with roses and dahlias allowed guests a quiet respite.

One of the most amazing aspects of the AYPE was the truly diverse array of buildings and exhibits that participated in the fair. County, state, and international buildings were erected for the exposition, as well as a number of fraternal and social organizations, which hosted exhibits. Buildings designed to showcase Washington State's contributions such as the Fisheries Building, which featured a live aquarium, and the Fine Arts Building, which housed 10 galleries of art from private collectors and public museums from around the world, also held special places on the grounds. Dozens of restaurants filled the grounds, as well as the Pay Streak amusement section, a model farm, and a military camp.

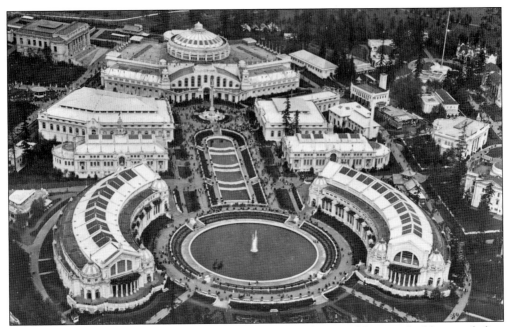

This aerial view of the grounds shows the Court of Honor and many of the main buildings including the U.S. Government Building at the top of the photograph. It was the largest building at the exposition with hundreds of thousands of historical items on display, including a desk where a rough draft of the Declaration of Independence was written and a pair of George Washington's eyeglasses. (UW27926z.)

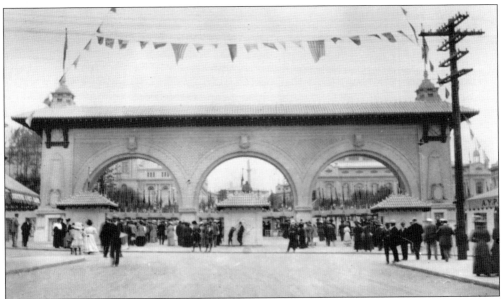

Within the main entrance gate, dozens of turnstiles allowed guests across the threshold into the fair. Beyond the arches, visitors caught their first glimpses of the U.S. Government Building on the right and the Alaska Building on the left. The main gate was located at NE Fortieth Street and Fifteenth Avenue NE. Ticket takers were trained to pick out fake coins from real coins and were constantly monitored for theft. (UW28075.)

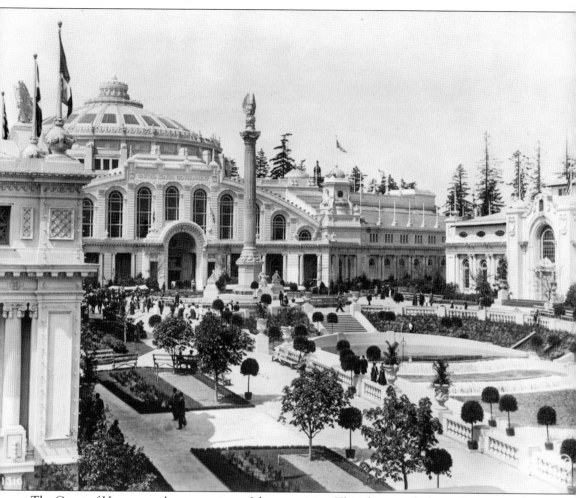

The Court of Honor was the centerpiece of the exposition. This photograph shows the courtyard surrounded by the U.S. Government Building in the center, the Alaska Building on the left, and the Hawaii Building on the right. The Alaska Monument towers over the center of the scene at the top of the Cascades Waterfalls. (Nowell x1310.)

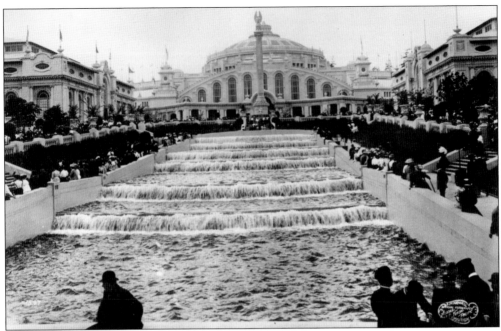

In this closer look at the Cascades Waterfalls, visitors take a load off by sitting on the edge of the fountain, which was designed by the famous Olmsted Brothers company. At the top of the Court of Honor stands the majestic U.S. Government Building with the Alaska Monument in front. (Nowell x1597.)

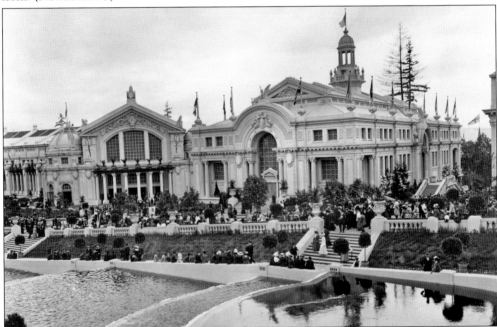

The European Building, on the right, displayed food and wares from 14 different European countries, including Germany, Holland, Russia, Italy, and Switzerland. The massive 60,000-square-foot Agriculture Building, on the left, exhibited a model cannery and railroad displays that showed how food was delivered to different parts of the country. (Nowell x1584.)

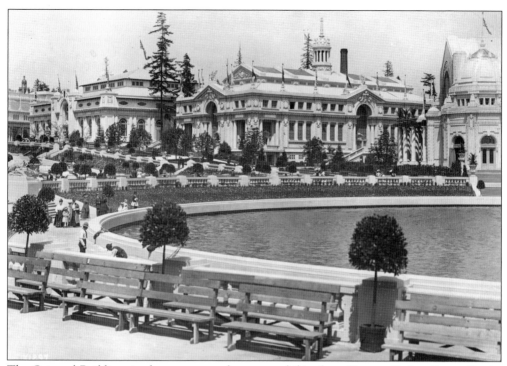

The Oriental Building, in the center, was home to exhibits from Greece, Turkey, Egypt, Persia, India, China, Korea, and New Zealand and focused on foods and wares manufactured throughout the Orient. The Hawaii Building, on the left, focused attention on the U. S. territory, people, and products. A 60-foot cement water tank was erected to display the islands in miniature where a volcano would emit smoke at regular intervals. (UW28048.)

The stately Manufactures Building stands across the Geyser Basin and fairgoers finely dressed in summer linens stroll among the gardens. The Manufactures Building featured exciting new technologies such as production lines of carpets, knives, scissors, silk, and silverware. The King County and Machinery Buildings are seen in the middle and left of the photograph. The Manufactures Building was razed in 1919 for the expanding campus. (Nowell x1299.)

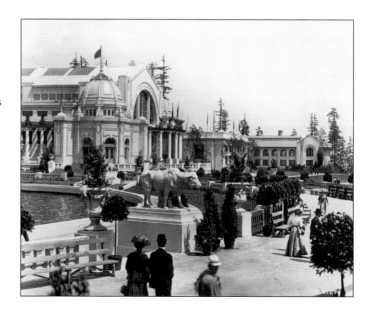

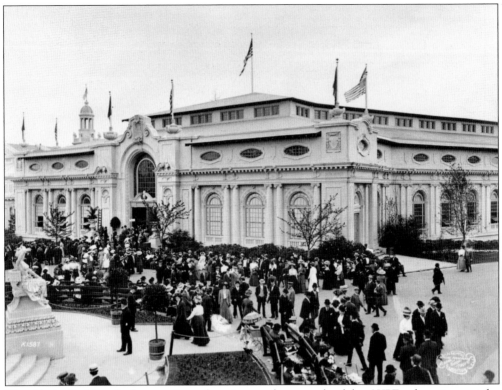

The Alaska Building had a prominent location on the grounds of the AYPE, where it sat at the top of the Court of Honor. It held Alaskan-native artifacts, exhibits of a dogsledding team, gold and marble from the state, and a number of agricultural products. (Nowell x1587.)

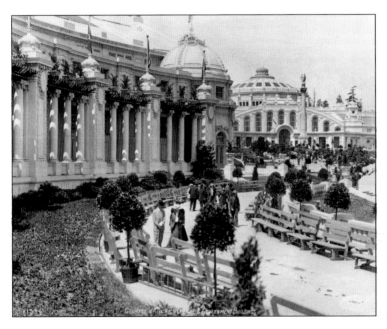

This beautiful view of the Agriculture Building, with the Alaska Monument and the U.S. Government Building in the background, was a key drawing point for visitors to the fair. The stark-white buildings were designed after French Renaissance architecture and curved around the Court of Honor flanking the Geyser Basin. (Nowell x1379.)

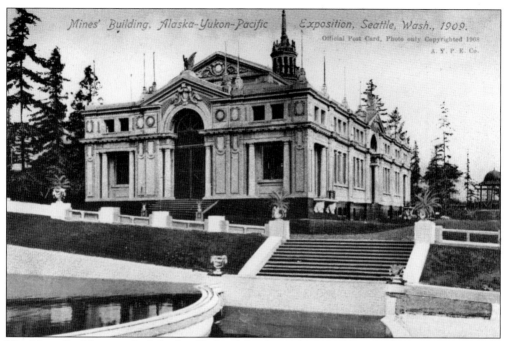

The Mines Building, to the left of and behind the Agriculture Building, had ore and other mined products on display. The newest techniques in mining and excavating that were used around Washington state and the Pacific Northwest were highlighted in its exhibits, and mine rescue work was demonstrated on a daily basis. (UW28067.)

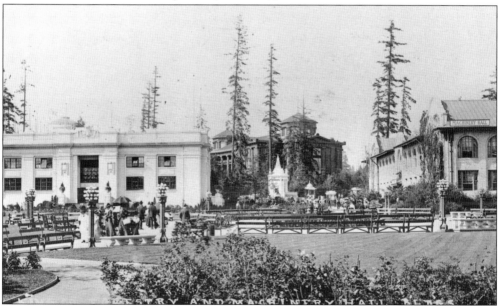

The King County, Forestry, and Machinery Buildings are seen in this image. The King County Building, on the left, featured products grown and manufactured around the region, including an outdoor strawberry garden. A small exhibit inside focused on the regrade project around Seattle showing an optical illusion of what the regrade looked like during the project and what it would look like after with buildings and skyscrapers. (UW28068.)

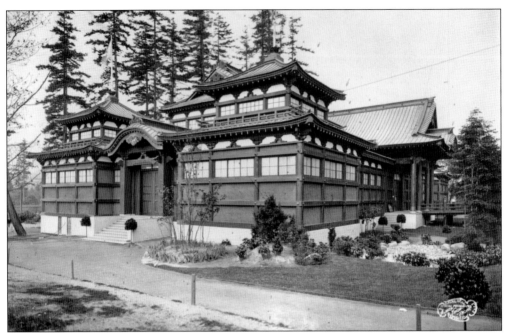

The Japan Building was just one way the AYPE allowed visitors to experience the exotic Orient for themselves. Exhibits of silk products and butterflies were on display throughout the building. Nearby a Japanese Tea House fed visitors authentic cuisine from Japan. It overlooked elaborate Japanese gardens with koi ponds and bamboo fences. (Nowell x2820.)

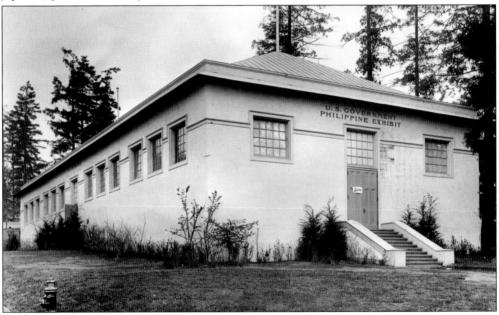

The Philippine Exhibit Building was an expansion of the focus on the Igorrote Village, the living display of indigenous Filipino people at the Pay Streak. This building housed exhibits, which included wax figures of natives building fires around their huts, basket weavings, cloth and other crafts, paintings depicting island life, and agricultural products. (Museum of History and Industry 1990.73.40.)

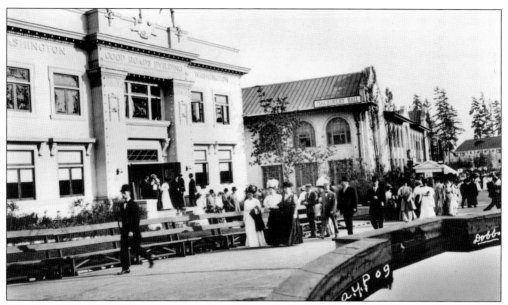

The Good Roads Building is seen on the right with the Machinery Building on the left. The Good Roads Building was constructed by the State of Washington to promote the construction of superior roadways. The Machinery Building exhibited large and small machines in motion and had a model foundry in the back. It became the University of Washington Engineering Hall after the fair. (UW28072.)

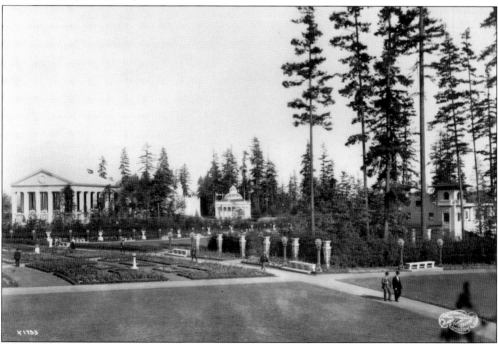

In this view with the stately columned Music Pavilion on the left, the relatively tiny Grand Trunk Railroad Building in the center, and the YMCA restaurant on the right, fairgoers meander the paths of the formal gardens. The YMCA restaurant was one of many eateries that fed the masses. (UW28049.)

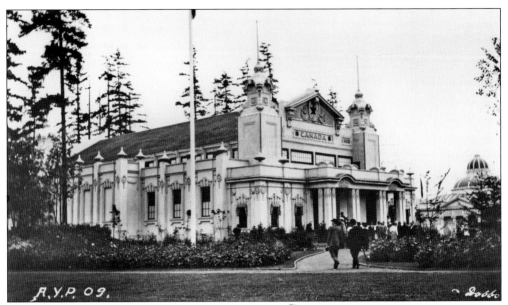

The Canada Building featured displays of regional wildlife (an array of dead and stuffed buffalos and elks) in its "wild animals of Canada" exhibit, fruits and other foods native to Canada, and other educational exhibits about the United States' neighbors to the north. The circular Grand Trunk Railroad Building is seen peeking through the trees on the right. (UW28073.)

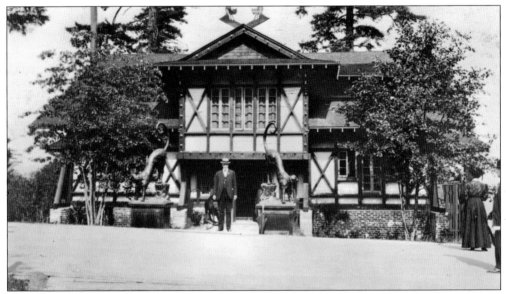

A lumberman's fraternity known as the Hoo Hoo built the Hoo Hoo House, which was famous for its two cat sculptures, whose eyes glowed green at night, posted in front. The house was a huge draw, and after the AYPE concluded it was used by the large number of lumbermen drawn to the fair. It served as the University of Washington Faculty Club until it was razed in 1959. (UW28074.)

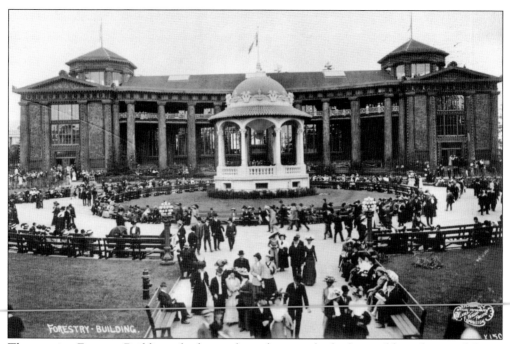

The massive Forestry Building, the largest log cabin ever built, featured huge logs used for its pillars. It featured natural wood throughout its interior and exterior and was built to showcase the Pacific Northwest's role in the timber industry, highlighting exportation of timber. The Nome Circle bandstand is seen in the foreground. (Nowell x1502.)

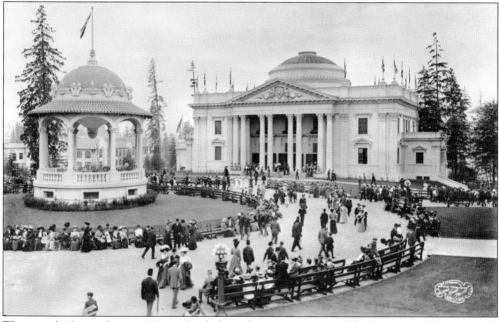

This view looks south across Nome Circle from the vantage point of the Forestry Building towards the Band Stand and the Oregon Building. The Oregon Building was the first state building erected, and it featured displays touting the wonders of Seattle's southern neighbor, including fruits, fish, forest, and mineral products. (Nowell x1573.)

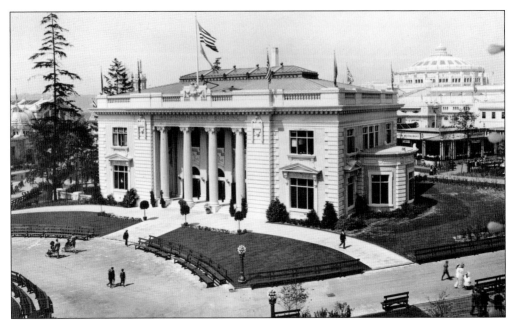

The Washington State Building, located just adjacent to the Court of Honor, was the official headquarters of the AYPE and housed all of the executive offices. This building was lavishly furnished for the purpose of entertaining dignitaries, including President Taft. Inside the building were an ornate grand staircase, ballroom, piano, and a ladies drawing room on the second floor. (Nowell x1700.)

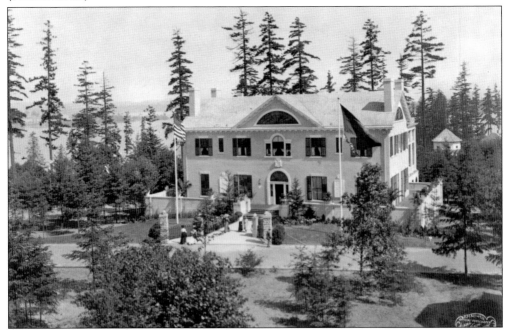

The New York State Building, located near the natural amphitheatre, was modeled after the home of former New York governor and senator William H. Seward, who was responsible for the purchase of Alaska. During the 1920s, the building was used as the University of Washington president's residence. It was then the Music Building until it was razed in 1950. (Nowell x1809.)

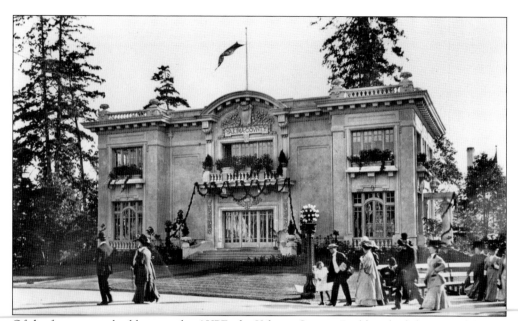

Of the four county buildings at the AYPE, the Yakima County Building had the most elaborate facade. The exhibits within were mostly dedicated to fresh fruits from eastern Washington such as apples, cherries, and apricots, as well as recently mined ore and a collection of wares made by the Yakima Indians. (UW28080.)

The California Building's entrance facade was designed in the Spanish mission style of architecture. There was an 80-by-80-foot skylight, which showered sunshine on the agricultural exhibits. Four immense ceiling paintings highlighted California's industry, subtropical gardens dotted the landscape outside, and the fruits of sunny California were prominently displayed. (Nowell x1673.)

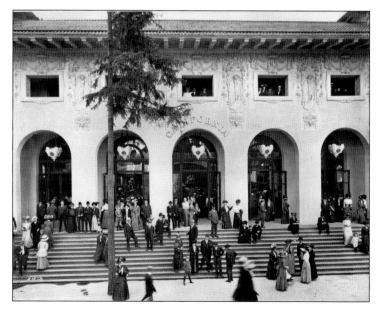

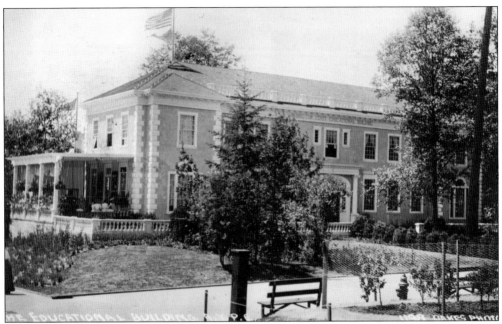

The Educational Building was paid for and built by the State of Washington to showcase exhibits from various schools around the state. A model school performed daily demonstrations by students from Olympia High School at work in the kitchen showing a variety of cooking techniques and the workshop where furniture and other products were built by hand. (UW28091.)

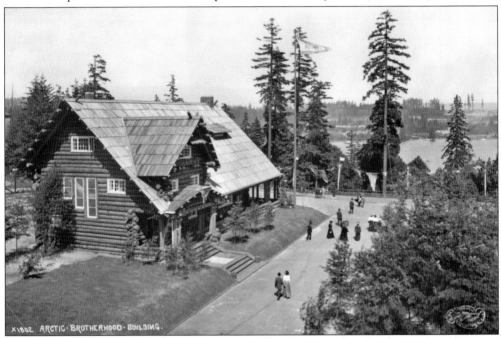

The Alaska Brotherhood Building was constructed as a meeting place for the northern fraternal organization and others groups interested in the Arctic region. The brotherhood held a lot of stake in the exposition since the members were some of the first to suggest having the AYPE. The exhibits seen inside were focused on products from Alaska. (Nowell x1802.)

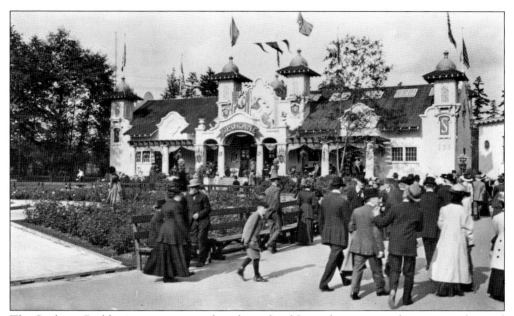

The Spokane Building was constructed in the style of Spanish mission architecture and served mostly as a lounge for fairgoers. It was built at the cost of $10,000 and resembled the Davenport Restaurant in Spokane. The walls were decorated with elaborate friezes made of grains and seeds from eastern Washington. Foods and manufactured products from the area were also displayed prominently in this building's exhibits. (LEE20064.)

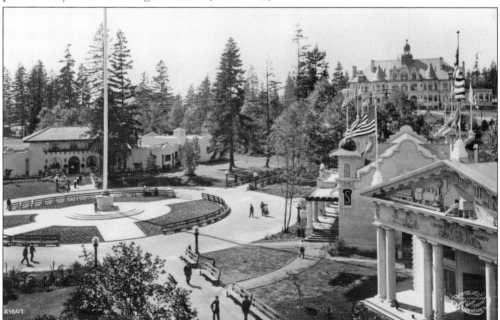

The Sons of the American Revolution (SAR) flagpole in Dome Circle was transported to the exposition with funds from the SAR organization. The Chehalis County, Spokane, and Idaho Buildings, as well as Parrington Hall, surround the flagpole. Denny Hall looms in the upper right corner and provides a clear picture of where the buildings were located relative to that landmark, which is still in existence today. (Nowell x1807.)

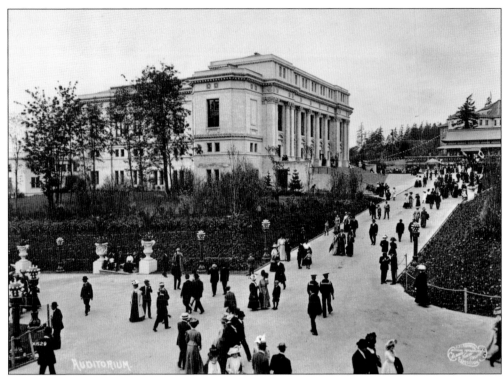

The vast Auditorium Building seated 2,500 people. It was used to host conferences and all special city, state, and county days throughout the exposition. This huge building greeted visitors on their left as they entered the main entrance gates. This was one of the permanent buildings to remain after the AYPE and it later became Meany Hall; however, due to an earthquake in 1965 the building was razed. (Nowell x1529.)

The American Woman's League Building, seen here illuminated at night, was furnished in arts and crafts period pieces. The league was established in 1907 by Edward Lewis and provided women with resources for education, social organizations, and care in old age. It also played a role in the women's suffrage movement, which was featured heavily at the AYPE. (Nowell x1738.)

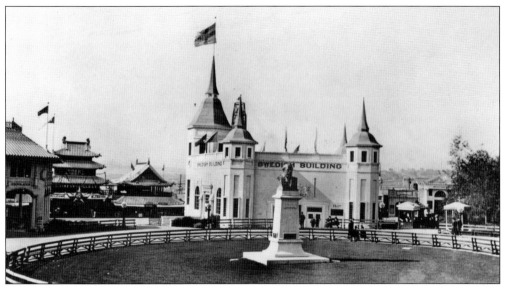

The Swedish Building, with its elaborate turrets, was one of the many buildings sponsored by foreign countries. The ground-breaking for the building took place on February 29, 1908, and was overseen by AYPE president John E. Chilberg, who was of Swedish decent. The Oriental Village and the Pay Streak can be seen in the background. (UW28079.)

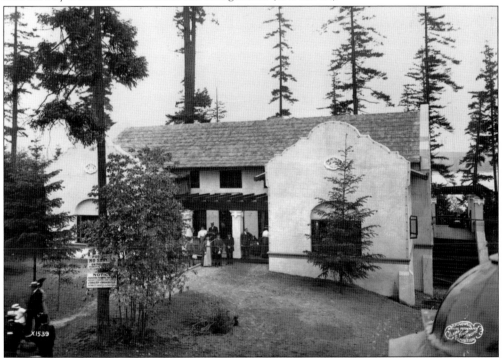

The Michigan State Building proudly exhibited products and foods from its region. The building held a prime spot in the fair, overlooking Lake Washington where one would be able to view Husky Stadium below from campus today. The building remained on the University of Washington campus after the fair and has been remodeled twice. It is now home to the Physical Plant Office. (Nowell x1539.)

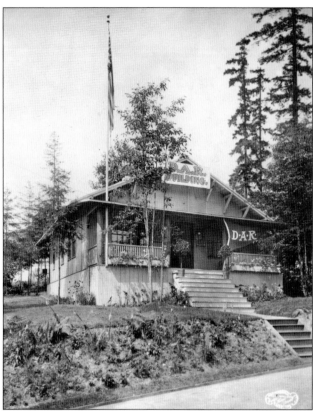

The DAR Building was sponsored by the Society of the Daughters of the American Revolution and housed historical exhibits and handicrafts from the DAR while providing a quiet respite for fairgoers. The DAR also sponsored the famous statue of George Washington, which stood at the entrance of the AYPE. (Nowell x2967.)

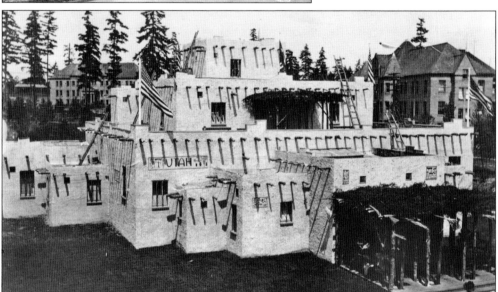

The Utah Building, which was a replica of a section of a Hopi pueblo from Utah, brought the American southwest to the Pacific Northwest. The exhibits focused on natural and manufactured products from Utah and held a special focus on the beet sugar industry. Invitations to participate in the AYPE were also sent to New Mexico and other southern states, but only Utah was interested in participating. (UW27737.)

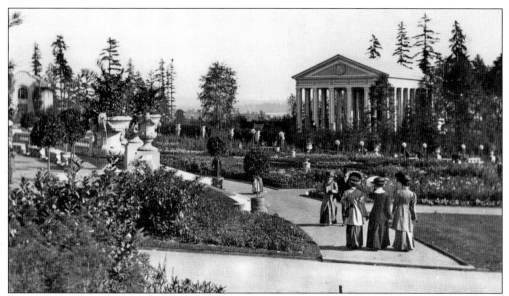

Guests flocked to the formal sunken gardens, located south of the Geyser Basin pond, to stroll among the vast fields of flowers, urns, fountains, and benches. The Music Pavilion, seen in the background with its many classic columns, held daily concerts by bands, musical organizations, and nationally renowned musicians and often had to seat an overflowing crowd in front of the building. (UW28077.)

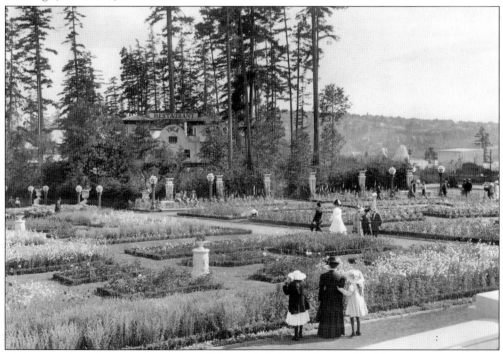

Visitors could enjoy stunning views of Mount Rainier as they strolled the sunken gardens set below Geyser Basin. With the Young Men's Christian Association (YMCA) Restaurant nestled in the trees, these fairgoers take in the roses and dahlias lining the walkways. Note the adorable little girls in the foreground enjoying the gardens with their caretaker. (Nowell x2282.)

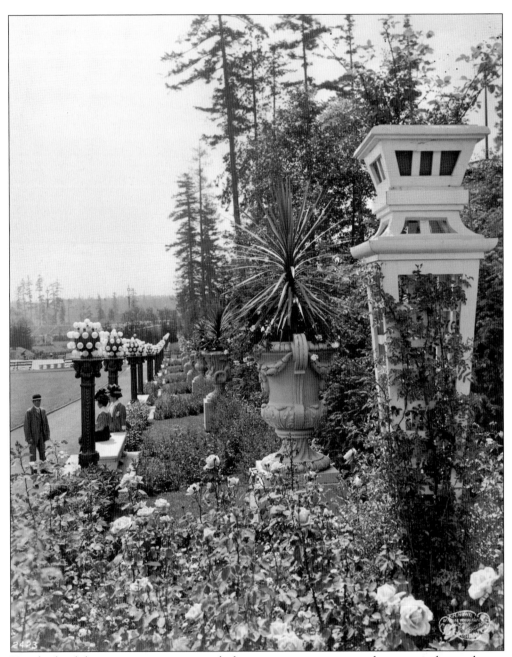

Hundreds of these intricate ornamental planters were set amongst the rose garden and were handmade especially for the exposition. They complimented the elaborate light fixtures that graced the paths of the gardens as well as throughout the entire fairgrounds. Visitors can be seen resting on one of the many garden benches. (Museum of History and Industry, 1990.73.106.)

The Vancouver Daily World headquarters was a unique newspaper office that was a direct design from the Hudson Bay Company bastion at Nanaimo, Vancouver Island, British Columbia, Canada. It was the only single newspaper that had its own building constructed for the AYPE. A Canadian delegation is seen posing in front of the building surrounded by cannons. (Nowell x3875.)

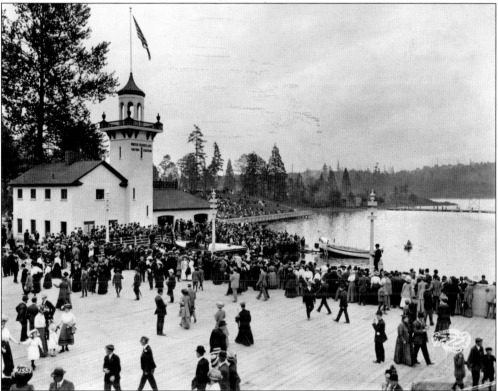

This south-facing photograph shows the U.S. Life Saving Station. The north end of Capitol Hill is shown on the right skyline, and the present-day canal entrance to Lake Union, under where the Montlake Bridge is now, is about where the grandstand sits in the center of the photograph. The U.S. Life Saving Station demonstrated water safety and life-saving techniques daily. (Nowell x1551.)

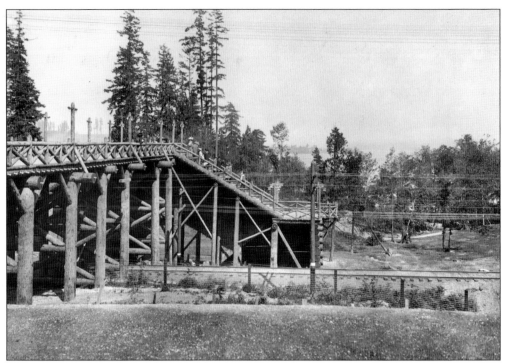

The railway trellis across the Northern Pacific railroad tracks connected the fairgrounds with the shores of Lake Washington. Fairgoers needed to follow forested paths and cross over this bridge in order to get to the exposition from the Lake Washington water entrance at the east of the AYPE. (UW28050.)

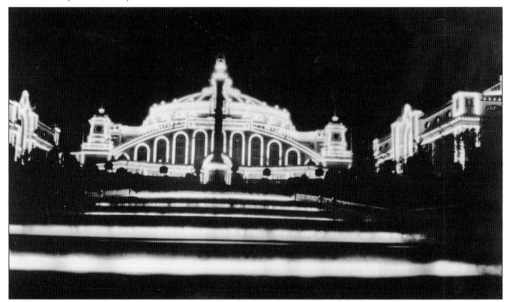

The Cascades Waterfalls and the U.S. Government Building with surrounding Court of Honor buildings are seen lit up at night. Each of the six waterfalls glowed with a different colored lamp. The entire fairgrounds were illuminated when the sun went down, providing a spectacular view for out-of-town visitors not accustomed to the nighttime illuminations. (UW28089.)

Four

EXHIBITS

The buildings themselves were a marvelous enticement to AYPE visitors who were drawn to their ornate architecture and grand designs. But what truly attracted guests came from inside these buildings: a plethora of sometimes strange and exotic, sometimes newly innovative, and always fascinating exhibits.

The largest exhibits were housed in the building that stood as the centerpiece at the fair, the U.S. Government Building. Hundreds of thousands of items were displayed in exhibits that represented 10 national governmental departments, including the Departments of War, Justice, Treasury, Interior, and Labor. A functioning model post office and a genuine mint, which pressed commemorative coins, were big hits. Copies of important documents were displayed in glass cases along with Congressional war and peace medals.

County and state buildings housed exhibits that paid homage to the vast bounty of each region. Each exhibit's host took advantage of the opportunity to show off the treasures of its home. Most of the displays consisted of fruits, vegetables, and other horticultural items native to the area, as well as exhibits on mineral, industrial, and transportation issues particular to each region. Visitors took delight in visiting the Utah Building, which was a unique pueblo that housed Native American handicrafts, and the California Building with its displays of life-size animals made from nuts.

The newest technologies of the day were exhibited throughout the fair as well. A working model dairy displayed the latest techniques in milk production, farming displays showcased innovations in irrigation, and forestry exhibits allowed guests to learn about timber processing and deforestation. The Manufactures Building was dedicated to the newest techniques in making products such as furniture and other wares for the home. It was recommended to allocate two days to take in all of the exhibits at the Machinery Building, which showed off the newest industrial contraptions on the market.

The exhibits highlighted early-20th-century technological advances, cultural artifacts from far-off lands, progress of western America, and the importance of fostering trade with Pacific Rim nations. Providing education and entertainment, the AYPE exhibits entranced visitors throughout the duration of the exposition.

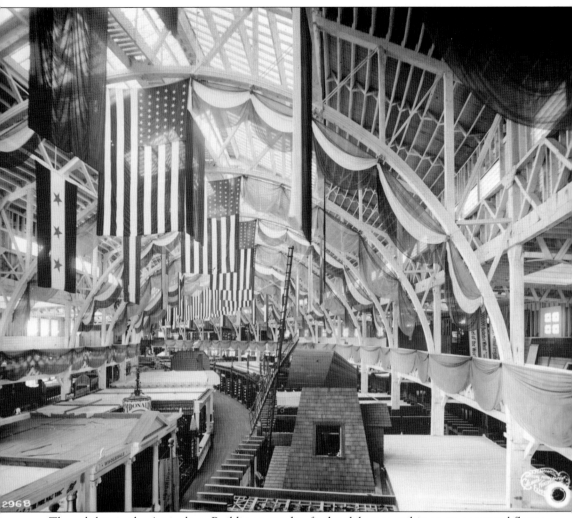

The exhibits in the Agriculture Building curved to fit the elaborate architecture, as several floors of displays showcased agricultural products, farming techniques, merchandise, and educational exhibits from Washington State's rural communities. Bunting and flags decorate the arched and sky-lighted ceiling over the elaborately constructed displays below. A model windmill can be seen in the lower center of the photograph. (UW27593.)

Inside the California Building was an arcade of wonders. Visitors were treated to the products of California, including fruits and nuts, chili peppers, olive oil, a bear made out of raisins, and a cow made out of almonds. Glassware gleamed from inside display cases. The building also boasted the world's largest book. (UW28054.)

Inside the California Building, an exhibit of dried fruits and nuts showed an elephant made entirely of walnuts. Its scale can be appreciated when compared to the tiny man at the far right of the photograph. The cow made entirely from almonds can also be seen at the center left. (Nowell x1741.)

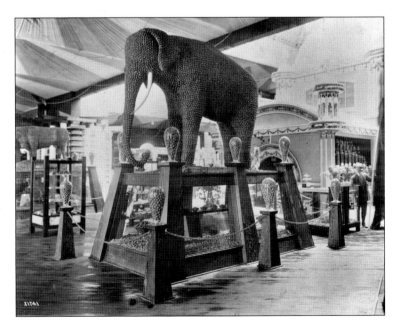

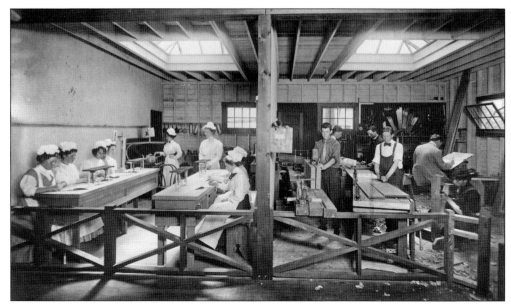

The Educational Building exhibit above shows a domestic-science kitchen and manual-training department. A letter accompanying this photograph states, "The manual training boys of the Olympia High School began on the 11 of June to finish and furnish three bare rooms-shop, kitchen and dining room. Picture shows shop and kitchen with boys and girls at work. Open sides for spectators. Boys are building workbenches, girls taking notes at beginning of demonstration lesson. Boys have built cooking tables doing gas pipe cutting and fitting. These rooms will be completely finished and furnished during the summer." The exhibit below shows female Olympia High School students doing a cooking demonstration in the model kitchen while onlookers watch the action. (UW27533, Nowell x2970.)

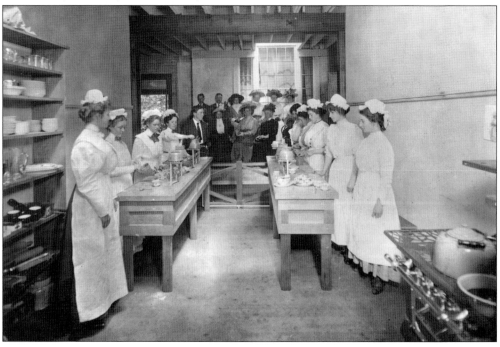

This Canadian Pacific Railway exhibit in the Agriculture Building featured large photographs of the fantastic Canadian scenery one could view on a long train journey. The exhibit focused on the traffic of agricultural products throughout the Northwest and not only featured locomotive transportation but also large ships, as seen from the models in glass cases. (UW28053.)

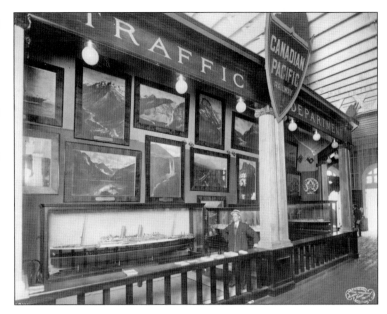

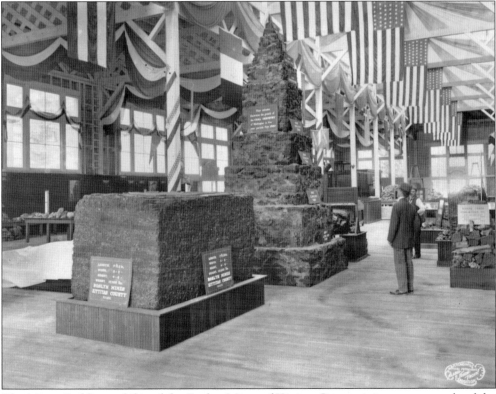

The Mines Building exhibit of the Roslyn Mines of Kittitas County is just one example of the many wonders on display. Here a man gazes at a pyramid of raw ore from the Cascade Mountains of Washington State. Other stacks of rocks and ore are scattered throughout this exhibit decorated with flags and bunting. (Nowell x1970.)

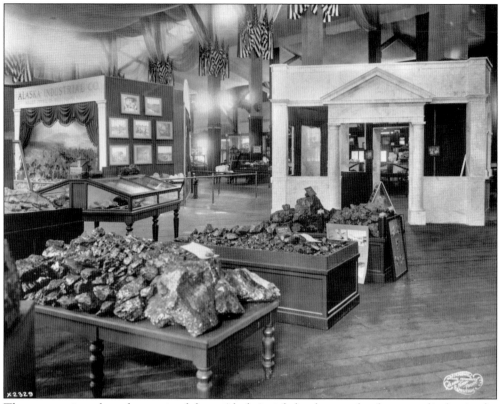

The many minerals and ore mined from Alaska's rich lands were forefront on display in the Alaska Building, which included a large, heavy archway made entirely of Alaskan marble that stood prominently in the exhibit. On the left in the background stands the Alaska Industrial Company model diorama surrounded by glass displays. (Nowell x2329.)

Artifacts of Alaskan natives were set in glass cases on display at this Alaska Building exhibit. Other exhibits from the Alaska Building consisted of $1 million worth of gold dust and nuggets that were displayed within a heavily guarded cage, which was lowered nightly into an underground vault, as well as a fish cannery exhibit. (UW13204.)

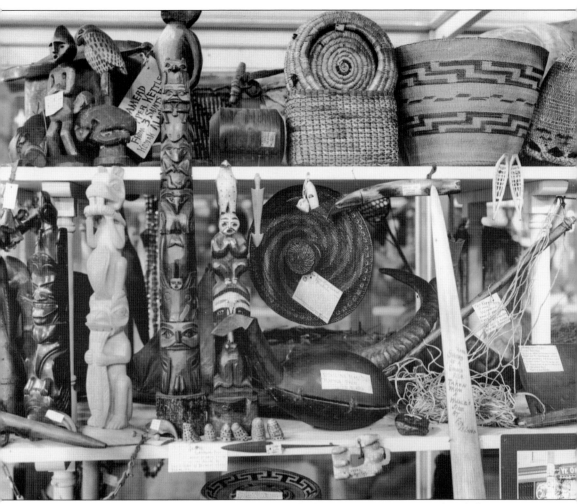

These American Indian and Eskimo artifacts, including miniature totem poles, dolls, woven baskets, tools, whale teeth, and pieces of art on display in the Alaska Building, were a huge draw for curious onlookers. Note the partial photograph of Seattle favorite Ye Olde Curiosity Shop, which itself has similar displays, in the lower right corner. (Museum of History and Industry 1990.73.140.)

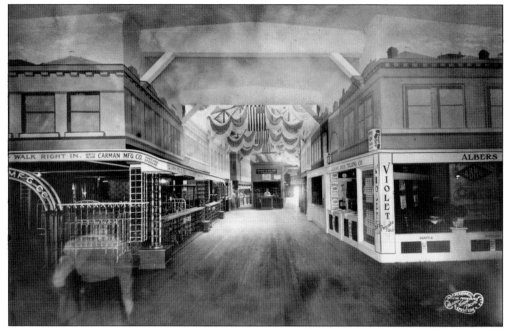

The King County Building was dedicated to displaying the complete array of products made in the county that contained nearly a third of the wealth of the entire state. The Carman Manufacturing Company exhibit on the left was just one such exhibit, displaying its many beds and mattresses. The facades of the displays all had a main street storefront theme to them. (Nowell x2760.)

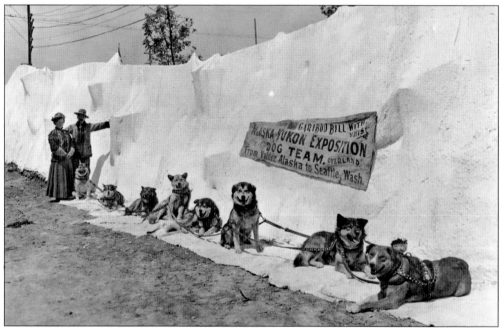

Caribou Bill, with his dog team, is seen in front of the Eskimo exhibit. The sign reads, "Caribou Bill with his Alaska Yukon Exposition dog team, overland from Valdez, Alaska to Seattle, Wash." Caribou Bill was a sort of mascot of the fair and had postcards and advertisements dedicated to him and his travels. (Nowell x1681.)

The dairy exhibit showing a model creamery was a working display of the newest technology in dairy farming techniques. The Dairy Exhibit Building was erected by the State of Washington to promote its dairy business. The small plain building stood innocuously between the Good Roads and Michigan State Buildings. (UW28057.)

Inside the Canada Building, the fruits of the nation were prominently on display. Besides the various types of apples laid out here, other exhibits included stuffed animals, animal head trophies, and beaver dams native to the Canadian wilderness. Note the elaborate mural depicting apple orchards on the right wall. (UW28056.)

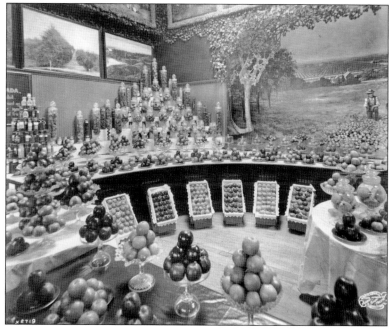

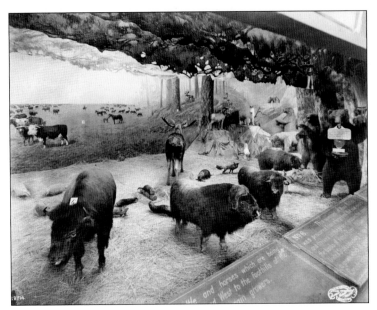

Stuffed buffalos, grizzly and polar bears, foxes, beavers, and goats stand on display in front of a lifelike mural depicting an idyllic field of cows and horses in this Canada Building diorama exhibit, which focused on preserved animals native to Canada. Guests walked amongst the exhibits reading the placards in front of the displays to learn more about the wildlife of Canada. (UW28051.)

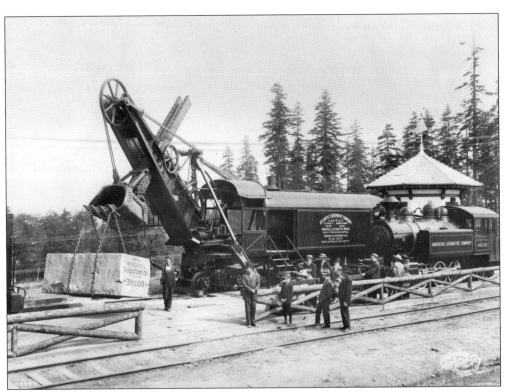

A favorite with visitors to the AYPE, steam trains stand on display in this American Locomotive Company exhibit. This particular train shows off its strength by lifting a 38,000-pound sandstone slab. The latest innovations in locomotive and transportation technology were displayed for fairgoers who could inspect the trains and equipment for themselves. (UW28052.)

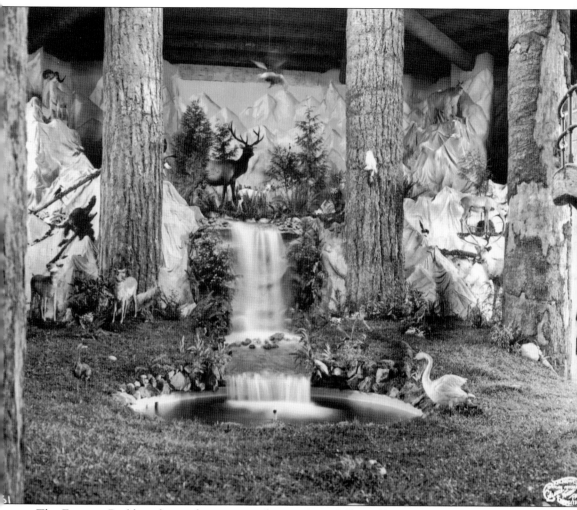

The Forestry Building featured its own rendition of an idyllic wilderness. An indoor waterfall rushes down to a pond set amongst actual fir trees, fake rocks and mountains, and stuffed deer and waterfowl. A balcony allowed visitors to view the spectacle from above. Other highlights from this building included a fish hatchery and an aquarium with live fish and seals. (History and Industry 1990.73.45.)

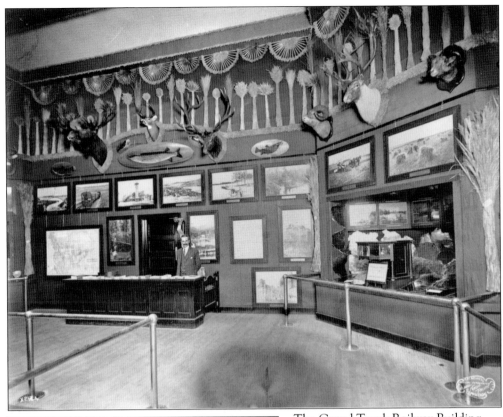

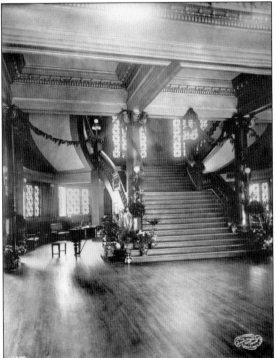

The Grand Trunk Railway Building exhibit showed scenes of wildlife from along the railroad with prominently featured trophy animal heads, as well as original artwork. The Grand Trunk Railway was the major rail system of Canada and was established in 1852. The company sponsored to have its own building to house the exhibits. (UW28055.)

This photograph of the interior of the Washington State Building highlights the ornate details of the grand staircase leading up from the ground floor to the upper floor drawing and rest rooms. There were weekly dances open to the public held in its ballroom, and President Taft was entertained within these rooms during his visit to the exposition. (Nowell x2386.)

Five

THE PAY STREAK

With all of the immense grandeur of the ivory buildings, sprawling gardens, and beautiful waterfalls and fountains, there was no bigger draw at the AYPE than the unique attractions of the Pay Streak. Fun and mysterious, educational and whimsical, the Pay Streak held surprises for the young and old.

Drawing its name from the riches of gold in creek beds claimed by miners during the Alaska Yukon gold rush, the Pay Streak amusement section of the fair was true to its name and brought in plenty of money to the exposition. It was calculated that it would cost a visitor $15.20 to purchase tickets for every single attraction on the Pay Streak, and the total revenue earned for the AYPE was over $90,000.

The amusement rides on the Pay Streak seem perilous by today's standards. The seatbelt-less L. A. Thompson Scenic Railway took visitors on a gravity-powered roller coaster adventure through plaster mountains. The Fairy Gorge Tickler led guests seated in metal buckets down a rickety slope, and other amusement rides, midway games, refreshment stands, theater revues, and novelties graced the streets of the Pay Streak.

Not all of the Pay Streak was innocent fun however. A difficult side of AYPE history was found in this otherwise enjoyable section of the fair. A tribe from the Philippine Islands called the Igorrotes was brought to the fair as a living exhibit. A fenced-in replica of their village was displayed in which the tribe's people worked and lived, and visitors could view the natives from afar. This display was thought to be educational, and the visitors to the fair took a paternalistic view of the Igorrote tribe, but by today's standards it was quite inhumane. While not the first World's Fair to have a living display of indigenous people, it doesn't diminish the harmful effects on Filipino peoples or AYPE history.

Whether it was the draw of viewing captive indigenous peoples, braving rickety thrill rides, visiting a fortune-teller, or taking in a bawdy burlesque show, the Pay Streak delighted visitors of the AYPE and was assuredly the most popular portion of the fair.

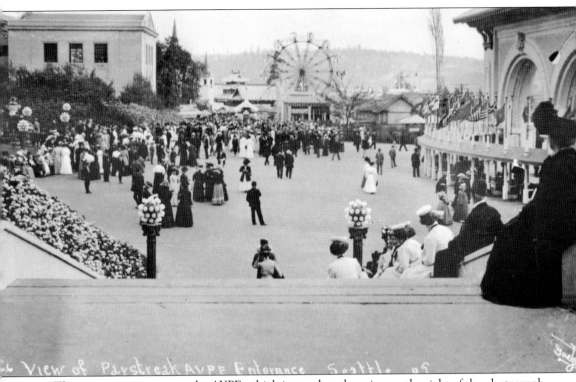

The main entrance gate to the AYPE, which is seen here looming on the right of the photograph, leads to the Court of Honor (unseen off the left of the picture), but for those wanting to have pure unadulterated fun, they would hang a right into the Pay Streak. The Ferris wheel beckons guests onto the midway. (Museum of History and Industry 2002.48.481.)

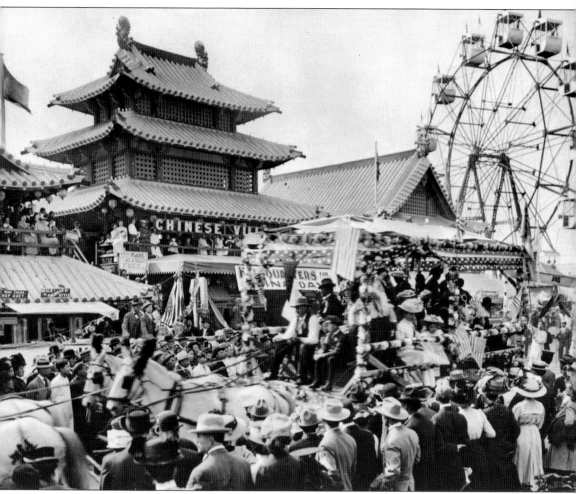

Spectators view a parade from the Chinese Village on the Pay Streak. The Pay Streak featured amusement rides, performances, food, animals, merchandise, barkers, music, dancers, and exotic exhibitions from around the world, including this elaborate Chinese pagoda. On the far right, the largest Ferris wheel in the world at the time entertained visitors and cost 25¢ per ride. (Nowell x3949.)

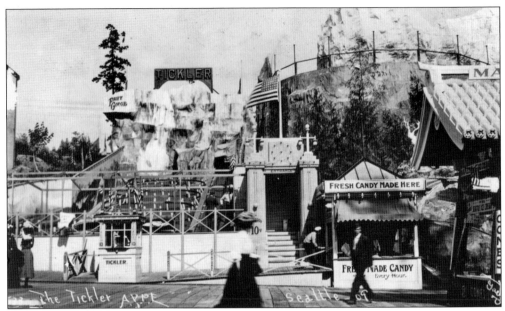

The Fairy Gorge Tickler amusement ride on the Pay Streak was a popular and tantalizing attraction. This humorously named ride placed brave visitors in metal buckets and sent them on a precarious, gravity-powered journey in rotating carts through a plaster mountain and down a zigzagging slope—all for the bargain price of one dime. (UW28090.)

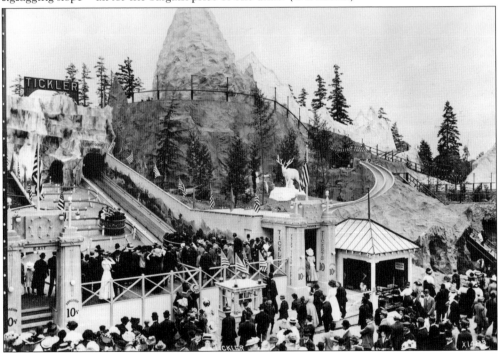

The Fairy Gorge Tickler ride can be seen on the left of the photograph with the Mountain Slide attraction sandwiched between it and the L. A. Thompson Scenic Railway in the background. The Mountain Slide ride had guests speeding down steep, slippery, and winding slides, presumably on gunnysacks. The amusement cost visitors only a nickel. (Nowell x1489.)

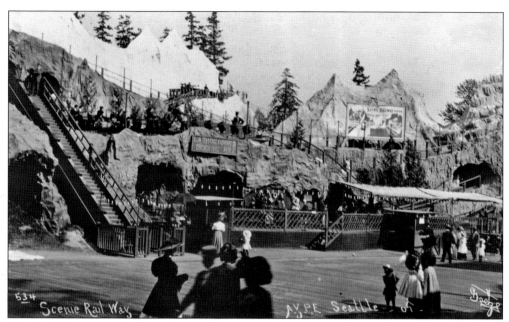

The L. A. Thompson Scenic Railway (above) was a precursor to Disneyland's Matterhorn Mountain ride and was a thrilling roller coaster with a large plaster mountain towering over the Pay Streak. The interior of the amusement ride (below) featured a giant wheel that powered the cars filled with adventurous passengers. La Marcus Adna (L. A.) Thompson, who was known as "the father of the gravity ride" and was famous for the Switchback Railway at Coney Island, created this 15¢ attraction. Thompson had more than 30 patents for roller coaster technology and designed dozens of well-known thrill rides across the United States and Europe. (UW28070, Nowell x2793.)

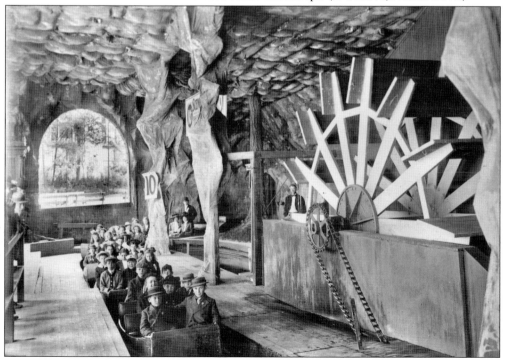

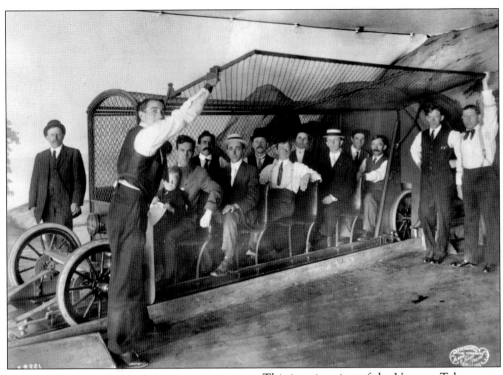

This interior view of the Vacuum Tube Railway amusement ride shows several brave souls, who paid 15¢, as they are about to be locked into a cage car and sent into the unknown by a compressed air jet through vacuum tubes. The ride was touted as being able to "revolutionize mail carrying" in the future and showed passengers what it was like to be a package. (Nowell x2221.)

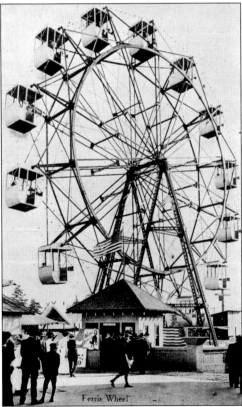

Ferris Wheel

The Ferris wheel, seen here near the head of the Pay Streak, was supplied by Eli Bridge and claimed to be the tallest in the world. A banner on the ride read, "You'll like Tacoma," presuming that fairgoers could see that far south, and a sign on the ticket booth read, "Scenic Ferris Wheel Highest in the World." The Ferris wheel was moved to Venice, California, after the AYPE. (UW28069.)

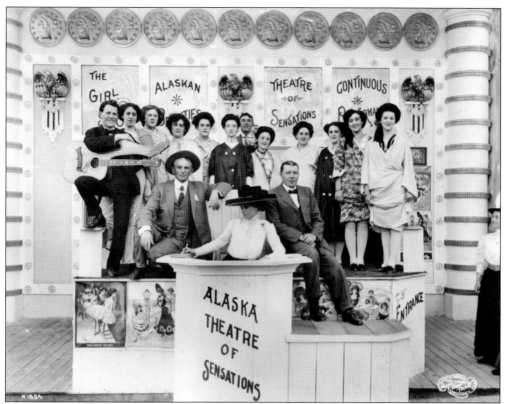

This portrait shows the actors from the Alaska Theatre of Sensations posing in front of the attraction. The man in the back row on the far left is holding a Knutsen harp guitar, and the other actors are singers, dancers, and players in this family-friendly attraction. A barker would stand behind the front podium to beckon in fairgoers to pay a mere 25¢. (Nowell x1854.)

This group portrait of gentlemen in silly costumes is believed to be none other than AYPE officials, as evidenced by a clearly recognizable president John E. Chilberg in the center back row wearing the white vest. Although most of the other men cannot be identified, the gentleman second from the right may be director general Ira Nadeau. This portrait was taken on the Pay Streak. (UW28058.)

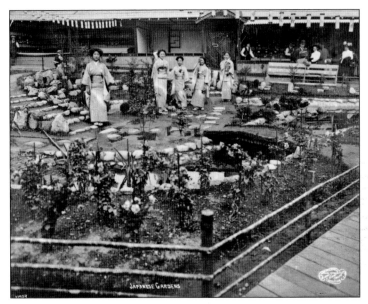

Women in geisha costumes pose amongst the Japanese Village gardens and koi ponds, also known as the "Streets of Tokio." Some of these women who worked in the Japanese teahouses were sorority girls brought in from Japan. The Japanese Village also featured shops selling native goods, dancers, and other attractions. (UW28059.)

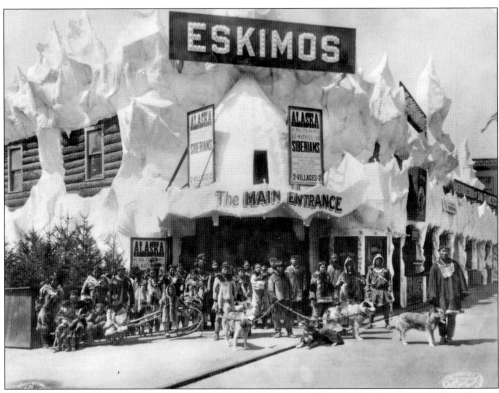

Eskimos pose with dogsleds outside of the Eskimo Village exhibit made of papier-mache. Almost 100 native people from Alaska, Labrador, and Siberia were brought to Seattle, so exposition visitors could learn about the original Northern inhabitants. Dogsled rides, dances, canoe racing, and igloos were part of the attraction. Misconceptions at the time included notions that Eskimos were wild, had no laws or government, and knew no god. (Nowell x1766.)

This classic midway game invites guests to sit in a chair that is a human-sized scale. The purveyor of the amusement would then guess the weight of the visitor. If he failed to guess within three pounds, the fairgoer would get the game for free. Seasoned carnies had many tricks up their sleeves to ensure that they almost always guessed the correct weight. (Nowell x2724.)

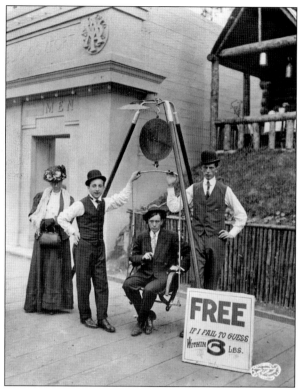

This whimsical attraction, based on the nursery rhyme "The House that Jack Built," was most likely the children's favorite and was perhaps a bit juxtaposed as it sat sandwiched between the entrance to the exploitive Igorrote Village and an attraction known as the Pharaoh's Daughter, which featured exotic Egyptian women on display. (UW28088.)

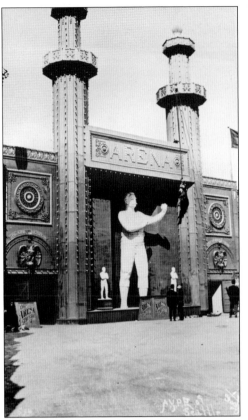

Along with the plays and musical acts performed here, the Arena Theatre featured a boxing and wrestling ring where spectators paid 25¢ for the privilege of watching their favorite matches. The theater was owned by John L. Sullivan and beckoned fairgoers with its massive strong man statue guarding the entrance. (Museum of History and Industry 1995.38.37.68.)

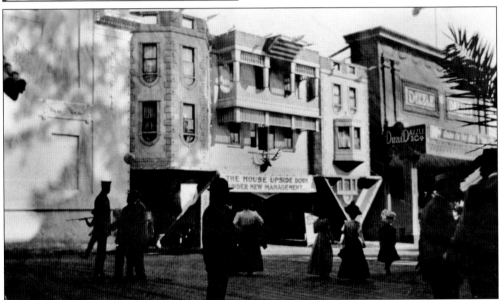

The Upside Down House allowed visitors to tour a house where everything was topsy-turvy. The attraction used science and optical illusions to trick the mind while fairgoers walked through the display on the "ceiling" while looking up at furniture and carpets on the "floor." The amusement only cost 10¢ per visit. (UW27933.)

The sign on the Haunted Swing amusement read, "Richest claim on the Pay Streak. The Magic Swing 10 cents for five dollars worth of fun." In this photograph, staff members, an AYPE security guard, and a clown pose in front of the attraction. One can only guess what sort of ride was inside or if indeed it was truly haunted. (Nowell x2206.)

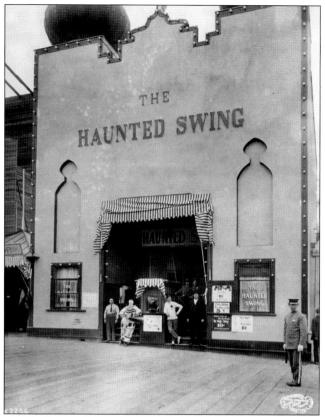

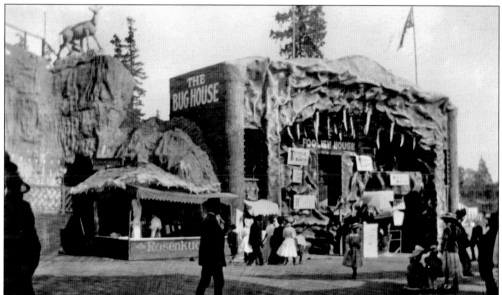

The Bug House and Foolish House together were also called the Temple of Mirth, which was a very popular attraction to fairgoers. This walk-through amusement was like a fun house, presumably with warped mirrors, dizzying staircases, and other elements to make the customer feel foolish. The building featured a pipe organ in the center alcove. (UW28087.)

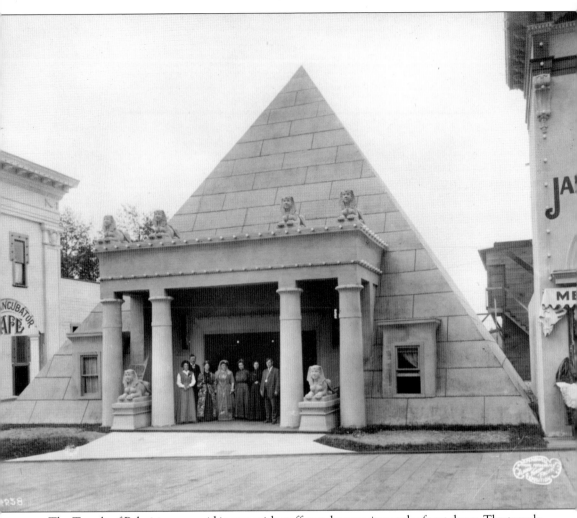

The Temple of Palmistry pyramid is seen with staff members posing at the front doors. The temple enticed visitors into its pyramid facade with promises of fortune telling and prestidigitation. Next door was the unfortunately named Baby Incubator Café, which helped pay for the bizarre but charitable exhibit of premature incubated babies that were put on display. (UW28060.)

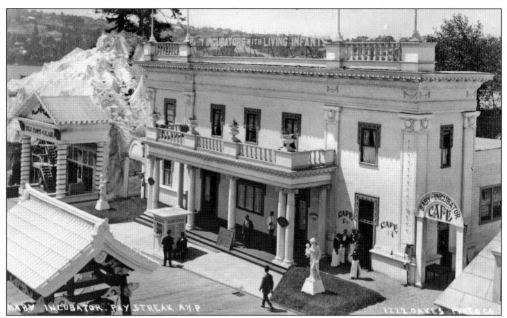

This exterior view of the baby incubator exhibit (above) shows the exhibit's place on the Pay Streak. The Baby Incubator Café, which helped the exhibit pay for itself, can be seen on the right. Inside (below) an around-the-clock staff watched over the premature infants. Baby incubators were a new technology in the United States and were not put into regular practice in hospitals until the 1930s. Despite mild controversy over displaying human children, these types of exhibits were featured prominently in 46 World's Fairs and helped showcase the need to legitimize incubation. The misconceptions at the time were that premature babies were better cared for at home versus in a hospital, and this display helped change people's thinking. No children were turned away, and parents were not charged for the use of the incubators. (UW27915, Nowell x1528.)

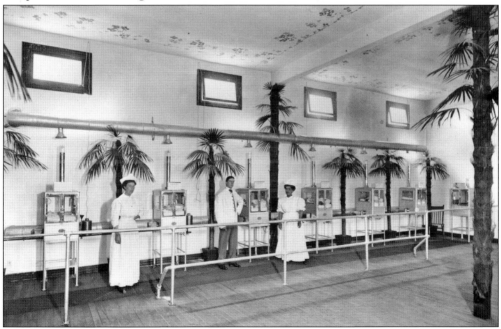

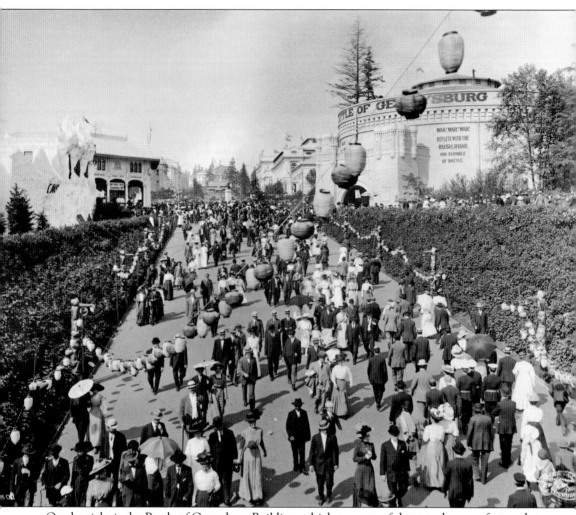

On the right is the Battle of Gettysburg Building, which was one of three cycloramas featured at the fair. The cyclorama was a 400-foot-wide, 50-foot-tall immersive painting, depicting the Battle of Gettysburg. For only 50¢, daily battle reenactments were staged in front of the painting, allowing visitors to feel as if they were actually there. (Museum of History and Industry 1990.73.151.)

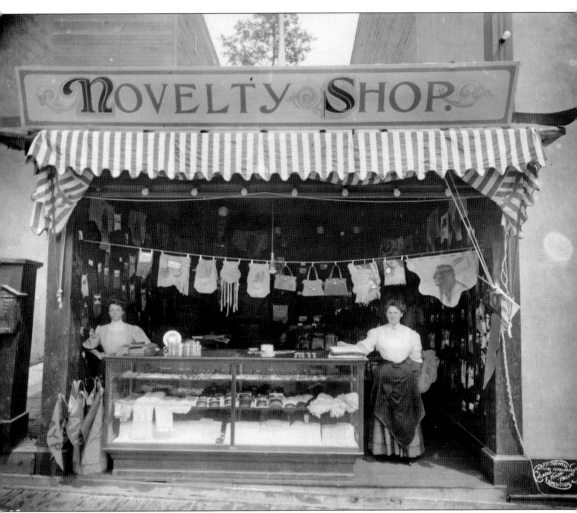

A novelty shop on the Pay Streak sold AYPE pendants, handmade leather goods, linens, trinkets, and other souvenirs to the masses. Two female shopkeepers attend to the merchandise at this shop, which was one of many to sell souvenirs to tourists. Today the many postcards, plates, and trinkets bearing the AYPE logo are quite collectible. (Nowell x2022.)

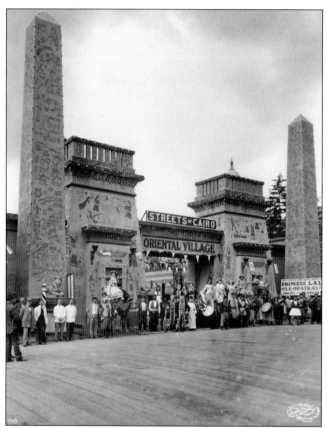

The Streets of Cairo and Oriental Village main entrance is featured here showing men and women in a variety of costumes of the Orient. The sign on the obelisk to the right reads, "Direct from the Levant, Europe's Greatest Sensation / Princess Lala in / Cleopatra's Dance with Death / Dancing with live African Asp." By no means controversial by today's standards, this amusement was definitely the tawdriest feature at the AYPE. (Nowell x1910.)

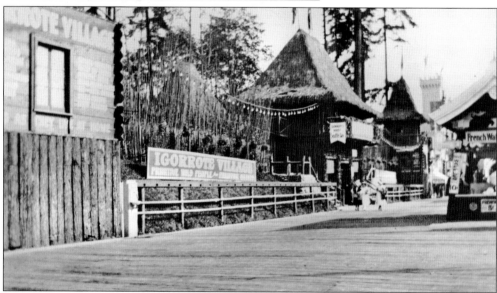

This sign beckons people to see for themselves the "primitive wild people" of the Philippines at the entrance to the Igorrote Village in the Pay Streak. The Philippine Islands were a recently acquired territory by the United States, and fairgoers were eager and curious to learn more about the native tribe. (UW28085.)

Philippine natives posing in front of a typical house on display were exhibited as living museum pieces. Though a difficult chapter of the AYPE, at the time it was quite acceptable to see these types of displays. In fact, the only real controversy was for the lack of clothing that the indigenous people wore, and there was an unsuccessful campaign to get them to put on pants. (Nowell x1686.)

The Igorrote people performed many ceremonial dances during their time at the AYPE. Besides showing the dances and other ceremonies of tribe members, there were demonstrations of craft and toolmaking, native dress and housing, and general daily activities, which were highlights for fairgoers in this popular human exhibit consisting of men, women, and children. (Nowell x2152.)

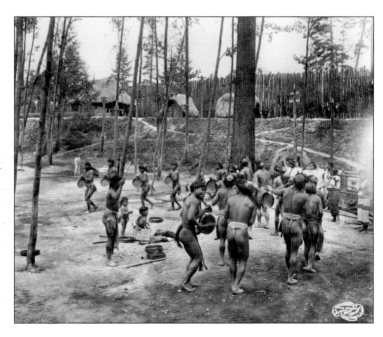

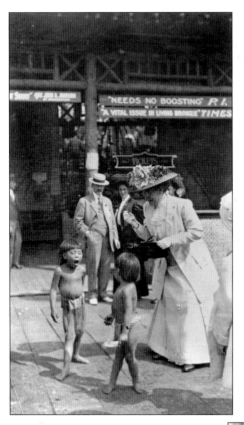

A woman feeding two Igorrote children is just one of the images that haunts the legacy of the AYPE. The sign on the entrance to the attraction read, "Igorrote Village—50 Primitive Wild People in a typical village from the Philippine Islands—50 Dog Eaters, Head Hunters from Mountain Fastnesses of Philippine Islands." (UW27768.)

This portrait is of the Igorrote chief on the left, director general Ira A. Nadeau in the center, and governor general James F. Smith of the Philippines on the right. The dignitaries visiting the Igorrote Village stand in stark contrast with the natives in dress and height and stature. (UW28061.)

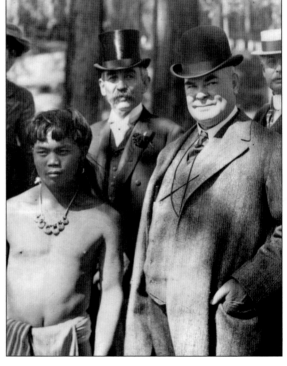

Six

EVENTS

For four and a half months, Seattle hosted over three million visitors to the AYPE, and on nearly every single day of the fair what was termed a "Special Day" took place. Different societies, groups, clubs, cities, counties, states, and countries hosted a variety of popular events in which all fairgoers could participate. These commemorative days were such a huge draw that throughout the duration of the exposition additional Special Days were added to the calendar.

Between the opening day and closing day ceremonies, over 270 of these Special Days took place. An amazing variety of these tributes were hosted during the fair, including University of Washington Alumni Day, Octogenarian Day, Grocer's Day, New Jersey Day, Theatrical Mechanics Association Day, Mystic Shiners' Day, and Esperanto Day to name a few. Each of the hosting groups organized activities and events to celebrate their members and to bring awareness to their causes.

Some associations used the popularity of the fair, with its draw of millions, to promote their objectives. The 41st Annual Convention of the National American Woman Suffrage Association was held in Seattle in July 1909 and used Suffrage Day at the AYPE to bring awareness to its movement. Six hundred conventioneers attended the exposition that day bearing banners that read, "Votes for Women." Speeches, meetings, and a dinner capped off the day.

Not all Special Days were dedicated to a positive focus on the AYPE. On Labor Day, September 6, also promoted as Seattle Day at the exposition, union members paraded in downtown Seattle to protest the fair's management to allow non-union labor in the two-year construction of the exposition. A picnic and rally were also held at Woodland Park with thousands in attendance, but protesters failed to uphold an all-out boycott of the fair.

It was more than beautiful buildings, amusements, food, and attractions that made the AYPE such an extraordinary World's Fair, it was the people who hosted and promoted these many special events that made the exposition such a rousing success.

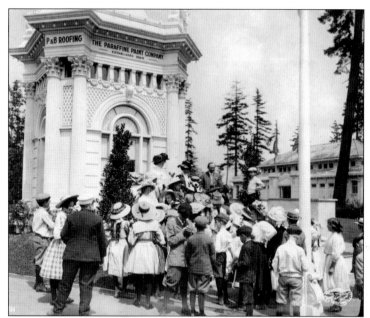

Schoolchildren's tours like the one seen here at the Paraffine Paint Company Building were conducted throughout the fair season. Washington State school superintendent Henry B. Dewey created a program that awarded diplomas to children for "exposition educational exploitation," and by the end of the fair more than 1,000 students were recipients. (Nowell x2981.)

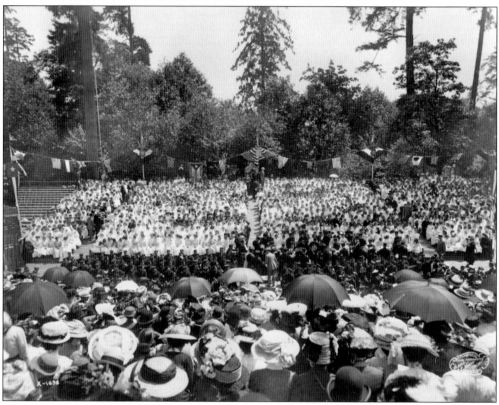

In this Children's Chorus performance at the amphitheatre, tots from Seattle public schools entertain the crowds. The first Children's Day was on June 5, 1909, and besides the featured concerts and children's tours and activities, it was an opportunity for Washington State to focus on state- and city-run children's programs. (UW28062.)

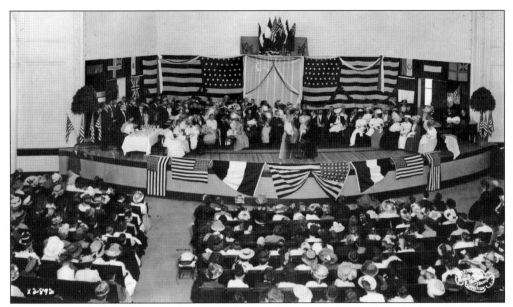

On July 20, 1909, thirty-seven infants were christened en masse during Baby Christening Day. Six ministers of different denominations presided over the ceremonies in the Auditorium Building while the founders of the AYPE oversaw the event. The only prerequisite for babies to attend was that they were born in June 1909. (UW28064.)

A group of children and young adults, dressed to the nines, poses for the French Fete on the stairs of the Auditorium Building. The French Fete was a reenactment of a French pageant featuring song and dance revolving around Revolution-era peasants and bourgeoisie. This one-day event was so popular that an additional day was added. (UW28063.)

June 3, 1909, was Military Day at the AYPE and kicked off many games and activities. Soldiers crowded the stands to watch a cavalry drill at the military athletic tournament that lasted several days. The U.S. Army is seen here displaying a revolver drill and tactics on horseback. A military camp was set up at a far south field on the grounds to host these games. (UW28081.)

Another cavalry artillery drill is seen here at the military athletic tournament held in the military camp stadium. The U.S. Army shows off its skills with cannon firing drills. The reverse side of this photographs states that this is the "Fourth Field Artillery, Mountain Battery, ready for action." (UW28082.)

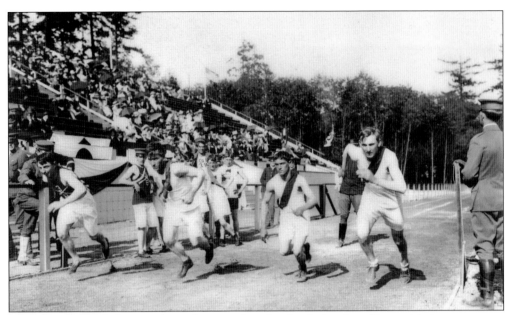

This photograph of a footrace shows the start of a mile relay during the military athletic tournament. It was held at the military camp near Lake Union, which had bleachers and a dirt track in its stadium. The 3rd Infantry won this race in 3 minutes and 52 seconds. (UW11742.)

The U.S. Navy baseball championship team poses here during the military athletic tournament in June 1909. The U.S. Navy team won the championship for the second division squadron. Besides sports like baseball and track, the military held contests on pitching tents, tug-of-war, maneuvering an obstacle course, and equestrian prowess; all were held in the same military camp location near Lake Union. (UW28084.)

This Ford Model T, car No. 2, was the winner of the transcontinental automobile race that began in New York City on June 1, 1909, coinciding with the opening of the AYPE. This car rambled into the fairgrounds on June 23 driven by Bert Scott with mechanic C. J. Smith. Henry Ford to the right of the driver is showing off his line of automobiles, which were one year old. (Nowell x2204.)

The gas-powered dirigible balloon was piloted by J. C. "Bud" Mars and is seen here readying the airship for flight. The dirigible was a much smaller aircraft than a Zeppelin and was steered using rudders and propellers. Seen here from left to right are R. T. Manning, F. C. Dittman, Stanley Vaughn, Fred Bell, Mrs. Marie Mars, J. C. Mars, and Otto Klives. (UW18361.)

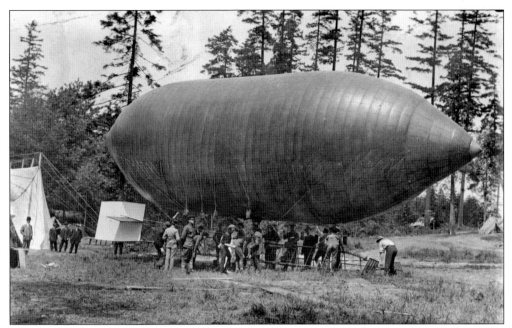

The dirigible balloon is seen tethered to the ground surrounded by helpers and onlookers. The airship, preparing for launch, is filled with a "lifting gas," as it was commonly called, and all of its knobs and levers are checked and double-checked. This balloon, which was called "Alaska Yukon Pacific Exposition," was also known as a blimp because of its non-rigid body. (UW18372.)

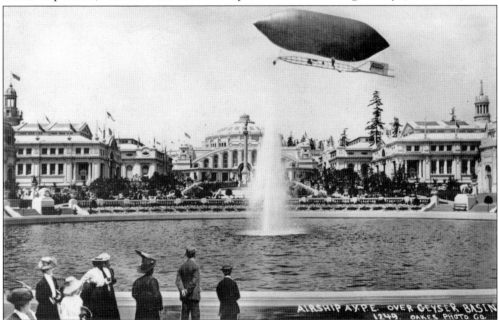

Fairgoers gaze upwards at the floating dirigible balloon over the Court of Honor. Different causes were advertised throughout the exposition, such as the silk banner stating, "Votes for Women," which was hung from the dirigible on Suffrage Day. It is said that as a boy, William Boeing saw his first manned flying machine, the dirigible, at the AYPE and decided to dedicate his life to building aircraft. (UW23078.)

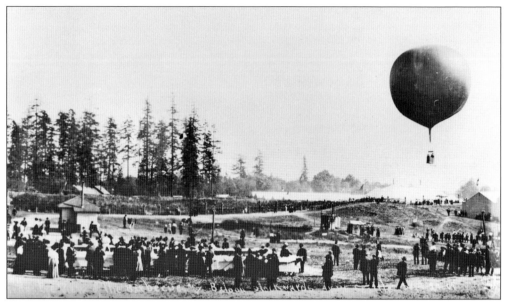

Visitors indulge in a delicious barbeque on one of the exposition's "Special Days," while others enjoy a ride in a tethered hot-air balloon. The balloon ride, which allowed guests unprecedented views of the fairgrounds as well as the surrounding Seattle area, cost fairgoers a whopping $1 per person. (Museum of History and Industry 1995.38.37.231.)

The first-prize Holstein calf seen here in the livestock exhibit was probably judged by President Taft himself; on October 1, the last day of his visit, Taft served on the panel of livestock judges. The exhibit was allotted a large swath of land at the south of the exposition and was billed as the largest show of its kind. (Museum of History and Industry 1990.73.160.)

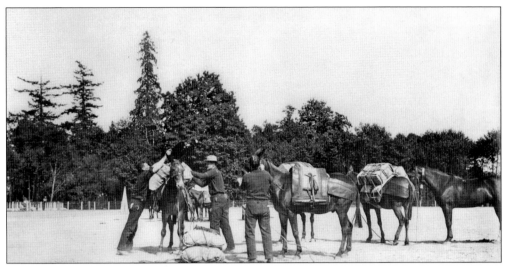

A packhorse-loading competition tested a participant's skills of speed and efficiency. Activities such as this contest were held daily at the AYPE and often focused on the era of the Alaskan gold rush and pastimes associated with that part of their recent history. This competition took place in the roomy livestock exhibit area. (UW28083.)

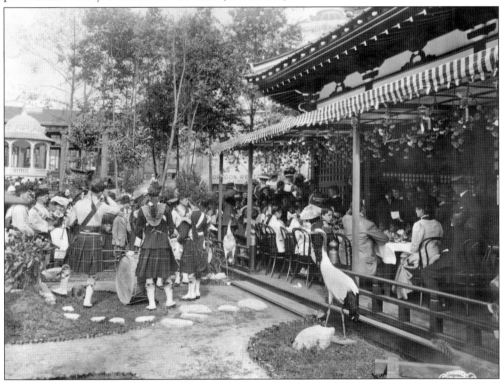

The Children of all Nations Day, also known as the "Children of Many Climes Day," involved all the international children living on the Pay Streak. They were dressed in native outfits, put on parade, and then fed dinner at the Nikko Café while this Scottish band played for them. There were children represented from Japan, Egypt, Morocco, Alaska, Siberia, Hawaii, and Assyria, as well as other countries. (Nowell x2992.)

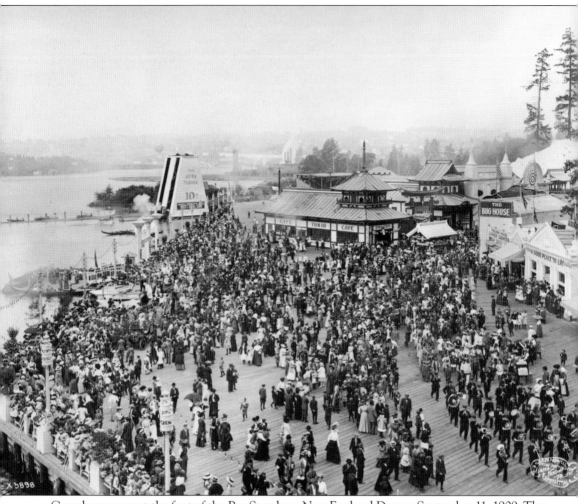

Crowds convene at the foot of the Pay Streak on New England Day on September 11, 1909. The New England Club of Seattle hosted events on this day, which included a faithful reenactment of the landing of the Mayflower at the shores of Portage Bay, as well as an authentic New England dinner prepared by wives of the club members. (Museum of History and Industry 1990.73.155.)

During Pres. William Howard Taft's visit to Seattle, which began on Wednesday, September 9, 1909, and lasted two and a half days, he toured the AYPE and visited sites around Seattle. Here he is seen in an automobile outside the New Washington Hotel (later called the Josephenium) where he stayed during his sojourn. (Museum of History and Industry 1983.10.8429.)

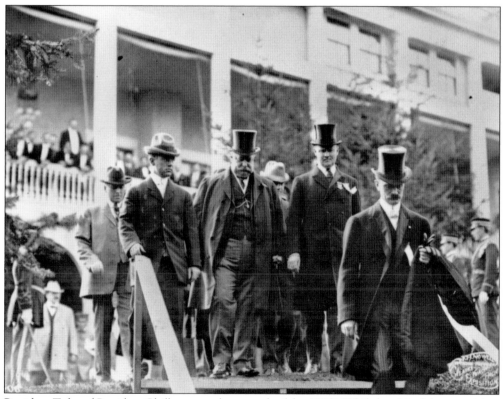

President Taft and President Chilberg tour the grounds of the AYPE. While he visited the exposition, Taft gave a speech on Alaska, had lunch at the New York State Building, and ate dinner at the Washington State Building. He also took time to attend and judge the livestock show held at the stadium. Taft was the fourth U.S. president to visit Seattle. (Nowell x1306.)

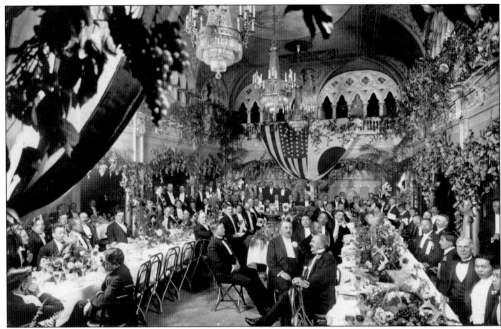

The Japanese Commercial Commission is seen here attending a banquet in their honor given by the Spokane Chamber of Commerce. This elaborately decorated feast was but one of the many activities planned for the important visitors; other events were a welcoming caravan when they arrived by steamship, tours of the AYPE grounds, and other special dinners. (UW18681.)

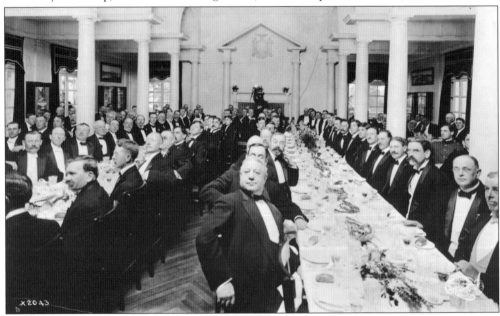

California Day, on September 9, 1909, culminated in this banquet held in the New York State Building with a dance that followed. Other festivities celebrating this special day were open to the public and included speeches, fireworks, and a messy and raucous "fruit toss" inside the California Building. Also present throughout the day were the "Portola Girls," 12 pretty young ladies performing cheers in support of California. (UW28065.)

A Canadian military marching band performs underneath the Vancouver, B.C. Welcome Arch in downtown Seattle. This scene was possibly the dedication of the arch, which was held in July 1909. The top of the arch, which was tinted with an ivory shade to match the buildings at the exposition, read, "Welcome to the Pacific Northwest / Vancouver B.C." (Museum of History and Industry 1990.73.162.)

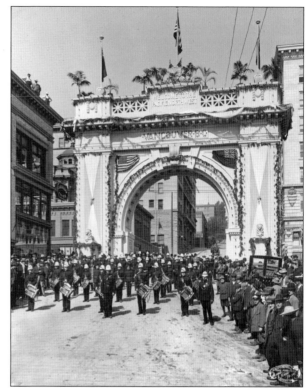

This parade going down Third Avenue was one of the many activities that took place in downtown Seattle, away from the main AYPE fairgrounds. This section of the parade featured automobiles decked out in leaves and flowers. This view is looking north from Columbia Street with the Central Building in the background. (UW28100.)

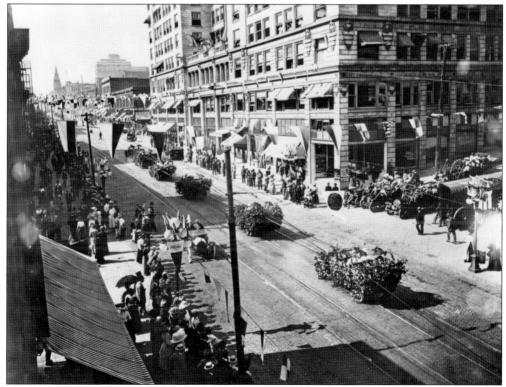

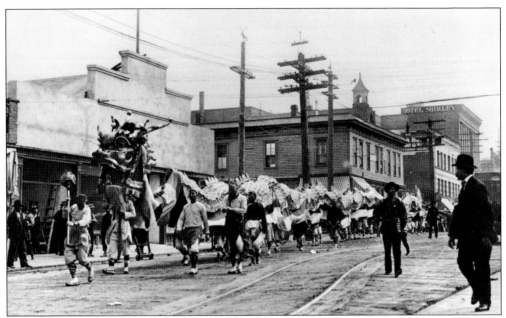

This parade down Fifth Avenue celebrated China Day on September 13, 1909, and featured a huge Chinese dragon being carried by dozens of Chinese-American Seattle residents. After the parade finished its downtown route, it performed an encore on the AYPE grounds. China Day, an extremely popular event at the exposition, culminated in a rousing fireworks display that evening. (UW28035.)

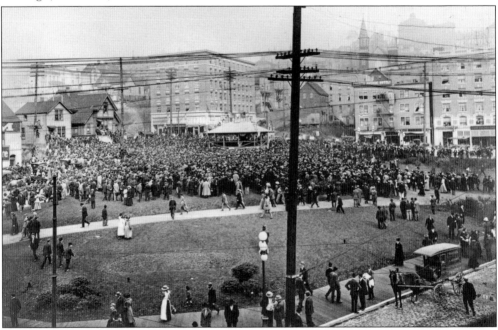

Despite the fact that much of the city was crippled with extensive regrading of the Denny area of Seattle, AYPE activities often extended into downtown, as seen here in this park near Third Avenue and Stewart Street. Here large crowds gather around a bandstand to hear an important speech. (UW28101.)

Seven

Gas, Food, and Lodging

Awaiting the throngs of visitors expected during the summer of 1909, the burgeoning city of Seattle prepared for the largest World's Fair to grace the Northwest. Local hotels, restaurants, and transportation companies opened doors to support the approximately two million out-of-state visitors. Hotels and restaurants sprung up overnight to support the overwhelming numbers of guests. One famous hotel built in 1909, which is now a historic landmark, is the College Inn located across the street from the former fairgrounds.

In 1909, few people had much by way of personal transportation. The automobile was considered a new invention and horse-driven carriages were for the wealthy. Luckily fairgoers had many transportation options to the exposition grounds located in the Brooklyn District 20 minutes north of downtown. Streetcars were a popular option, and two additional streetcar lines were created, bringing the total of three cars from downtown to the Brooklyn District. Steamboats offered passenger's lakeside transportation advertising ways to "avoid the dust and dirt of the over-taxed car lines." The *Cyrene* ferried passengers from as far as the small town of Kirkland, located on the northeast side of Lake Washington, as well as local Seattle neighborhoods. Rail lines offered vacation packages for travelers interested in visiting the sites of the national parks as well as the AYPE.

Exposition visitors had many options for food and beverage. Free drinking fountains fed with fresh water from the Cedar River watershed were placed evenly throughout the fairgrounds. Additionally, the fair had many restaurants to choose from, including Hires Root Beer, Pioneer Inn, Nikko Palace Café, Army and Navy Tea Room, and smaller refreshment stands. Firmin Michel Roast Beef Sandwich Restaurant was one of the most popular restaurants, bringing in over $10,000 in revenue. Apparently roast beef was a popular meal item at the time.

Tourism was at an all-time high during the AYPE, and local businesses prospered. Providing transportation and basic needs to the visitors were critical to the exposition's success. The fair succeeded tremendously as was evident by the close to four million happy visitors.

In the months before the AYPE, two new double-track streetcar lines were built by Seattle Electric Company from downtown Seattle to the fairgrounds. One line followed Twenty-Third Avenue and one crossed the Latona Bridge, which was where the Interstate 5 Ship Canal Bridge stands today. This streetcar carries Scandia Club members to the exposition. (UW7566.)

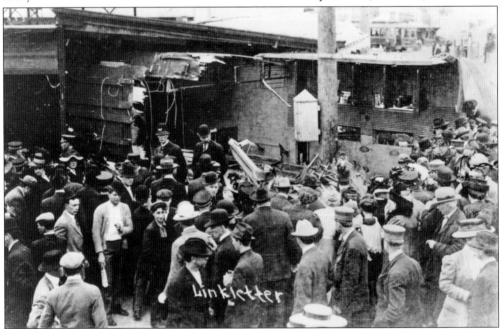

When the brakes failed, a Seattle Electric Company streetcar jumped the track at NE Fortieth Street and Fourteenth Avenue NE (later to become University Way), right across from the main AYPE entrance. The streetcar carrying 80 people from the Wallingford district crashed into several concessions along the road. One man died and 55 were injured. (UW28104.)

The Chambers automobile, seen here driven by Leslie Bigelow, was only the second taxicab in operation in Seattle. This may have been a more decadent form of transportation than trolleys or horse-drawn carriages, but a few of the rich were able to indulge. Rail magnate James J. Hill hired this car for his party and him to travel to the exposition, and he left a whopping $60 tip. (UW28102.)

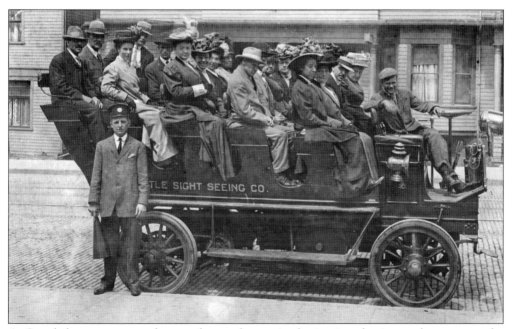

As Seattle became more and more of a popular tourist destination, due in very large part to the draw of the AYPE, companies that catered to travelers started to pop up. Here a tour bus from the Seattle Sight Seeing Company, filled with tourists dressed in their finest, poses on a cobbled downtown street. (UW26381.)

The passenger steamer *Cyrene* catered to AYPE visitors who arrived to the fair over Lake Washington. Fairgoers could board the steamship in Kirkland and float across the water to the Lake Entrance at the east of the exposition. This ship was built by Capt. John Anderson specifically for the purpose of transporting visitors to the fair. (UW28103.)

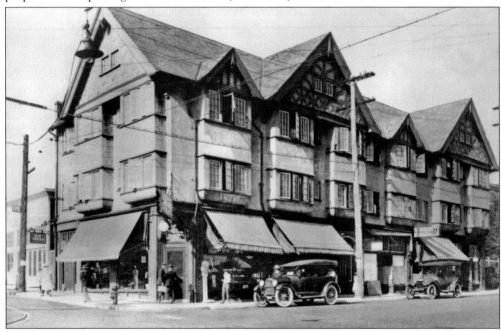

The College Inn was built by Seattle entrepreneur Charles Cowan to house the many visitors to the exposition and opened on the same day as the fair, June 1, 1909. The inn had changed hands many times throughout the century but always maintained its function as a hotel—even today. It is one of few commercial structures from the AYPE that is still around today. (UW4619.)

This simple boardinghouse on Fifth Avenue between Cherry and James Streets in Pioneer Square, in downtown Seattle, was a typical place that tourists could lay their heads after a long day at the AYPE. Since not every person could afford an expensive hotel room and since places to stay were becoming scarce, Seattleites opened their homes for the lucrative prospect of boarding out-of-town visitors. (LEE302.)

This scene of downtown commerce on Yesler Way was what greeted an out-of-town visitor interested in finding a good hotel and doing some shopping. The building on the right was the Norman Hotel sitting next to A. Bridge and Company men's furnishing store. A streetcar stands out front, waiting to take guests to the fair. (UW2270.)

Washington pioneer Ezra Meeker gained the rights to large tracts of the Pay Streak and painstakingly outfitted these areas with artifacts and replicas from early settlements. The Pioneers Restaurant and Ezra Meeker's Ranch were two features that allowed visitors to experience the Northwest in its pioneer days while catching a bite to eat. (UW28092.)

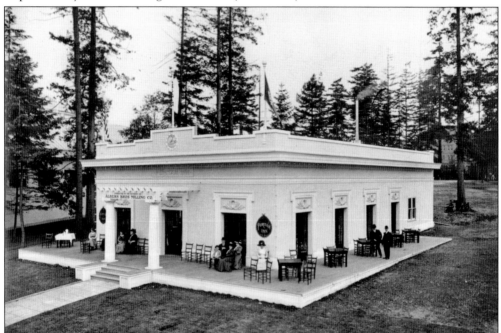

The Pay Streak featured the Puritan Inn, which was a popular restaurant serving guests of the AYPE. The sign out front stated, "Conducted in the interest of Albers Bros. Milling Co." This company was created in 1895 by Bernhard Albers and his four brothers, and the restaurant made over $6,000 for the family. (Nowell x1537.)

Hungry visitors of the Pay Streak could pay 50¢ for a "regular dinner" at the Palm Cottage Café. Here staff and guests pose at the entrance of the restaurant whose sign boasts that "Mrs. Corinne Simpson, proprietress" runs the show. The California Indian Museum is the neighbor directly to the right. (Nowell x2226.)

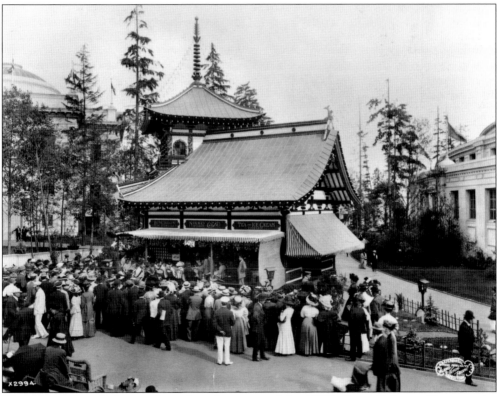

The Nikko Palace Café was a huge draw for visitors of the AYPE. Centrally located between the Oregon and Manufactures Buildings, the restaurant was styled after a Japanese tearoom and was run by natives from Japan. The menu, however, was thoroughly American and featured such fare as roast beef sandwiches. (Nowell x2994.)

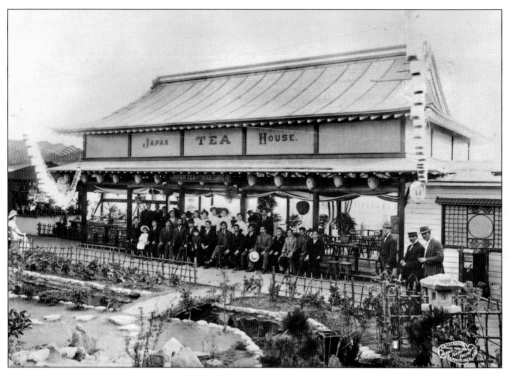

The Japan Tea House was part of the Japanese Village and the "Streets of Tokio" and served authentic Japanese cuisine including tea and rice cakes. Japanese dignitaries were the guests of honor during their visits, and they could stroll among the gardens and feed the koi that occupied the ponds. (UW28066.)

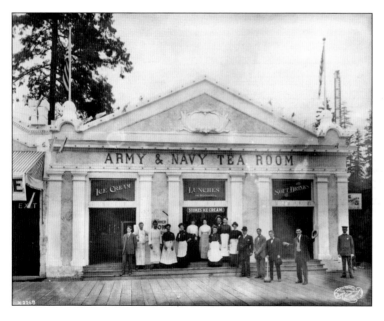

Located on the Pay Streak, the Army and Navy Tea Room was sponsored by the U.S. military and served a light fare of lunch, ice cream, and cold beverages. Advertisements for the restaurant boasted that it was "among the first-class refreshment stands on the grounds." Tearoom employees are seen here proudly posing for a photograph. (Nowell x2268.)

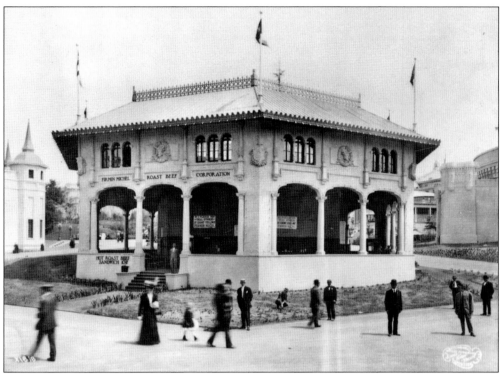

Visitors to the Firmin Michel Roast Beef Corporation restaurant enjoyed gourmet roast beef sandwiches. The corporation was a familiar sight at World's Fairs, as it had made previous appearances at the Pan–American Exposition in Buffalo, New York, in 1901 and the 1904 St. Louis World Fair. The building was located in close proximity to the Eskimo Village exhibit near the Pay Streak. (Nowell x1818.)

The Golden Rod Inn was also known as the Acme Tea Parlor and was located right next to Igorrote Village on the Pay Streak. The sign on the front of the building stated that this restaurant was a "modern domestic science kitchen." It served American cuisine to hungry fairgoers. (Nowell x2252.)

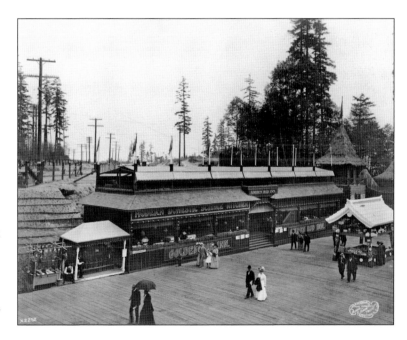

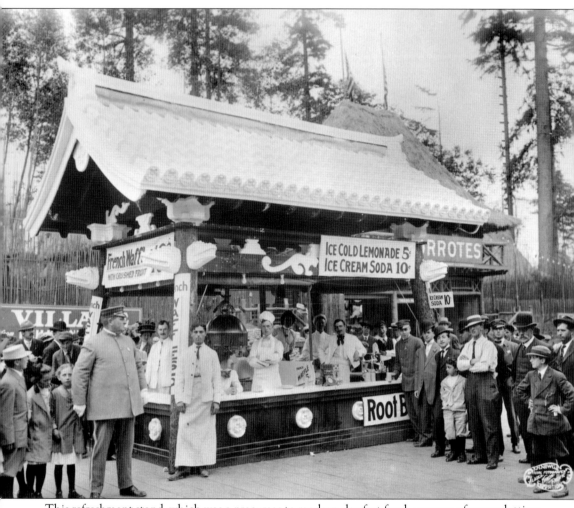

This refreshment stand, which was a precursor to modern-day fast food, was one of many dotting the Pay Streak. Children lined up to buy cold lemonade, root beer, ice cream, and authentic "French waffles with crushed fruit." This food stand served fairgoers coming and going from the Igorrote Village. (Nowell x2726.)

Eight

OPERATIONS

The AYPE was a huge undertaking for the city of Seattle. A small up-and-coming metropolis was to play host to over three million visitors, and local neighborhoods and the fairgrounds themselves needed to develop the infrastructure of a small city. Entire sewer and electrical systems were established as well as fire, medical, roads, and transportation departments.

The Brooklyn District, now known as the University District, played host to the AYPE and made many neighborhood improvements. It was a race to complete an additional new sewer line, two new double-track streetcar lines, and new roads with sidewalks and street lighting. Paved streets replaced dirt roads that tended to get muddy from the rain, a threat to the timely completion of these projects.

The fairgrounds had miles of underground sewer lines, water and gas mains, and electric conduits. During the summer, guards caught six people who were guilty of illicitly entering the fair via an underground quarter-mile tunnel and out through a manhole. These entrance fee dodgers were called "muddy shoulders," and it was estimated that nearly two thousand gained free entry before the manhole was discovered and sealed.

A fire station and emergency first-aid hospital were built for the safety of the millions of guests who made their way through the fairgrounds during the summer of 1909. Fire chief Harry W. Bringhurst oversaw the fire department, which was kept busy throughout the exposition with both large and small fires, including the near disaster when a brush fire crept within 40 feet of a shed holding fireworks, and smaller-scale blazes when women's skirts caught fire from gas lamps.

Guests did not necessarily pay attention to the changes and the massive infrastructural undertakings that the city implemented. These changes weren't the highlights of the fair, but they insured visitor's comfort and safety while attending the exposition.

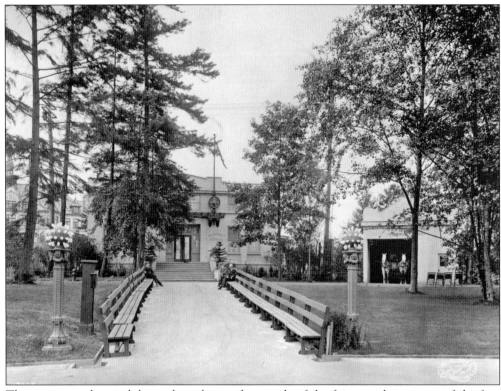

The emergency hospital, located on the northeast side of the fairgrounds, was one of the first buildings completed at the AYPE so that it could treat patients during construction of the fair, and it went on to treat patients before and after the exposition. From the time it was opened, 2,229 patients were seen throughout the summer. Note the horse-drawn ambulance parked in the garage. (Nowell x2365.)

In this view of the interior of the emergency hospital, different medicines, surgical instruments, and bandages can be seen surrounding a patient table. Visitors could get first aid for all sorts of ailments, including heat stroke, dehydration, accidents, and even a gunshot wound, which one man obtained in a rowdy brawl at the Streets of Cairo. (Nowell x86.)

The AYPE Fire Station, located behind the Hawaii Building, was called into service only twice during the run of the exposition. Once on March 30 when a fire broke out in a contractor's shed near the Forestry Building and once on September 18 in the Foundry. Of all the World's Fairs at the time, the AYPE had the best fire safety record. (Nowell x1356.)

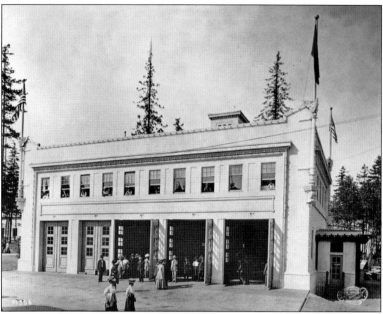

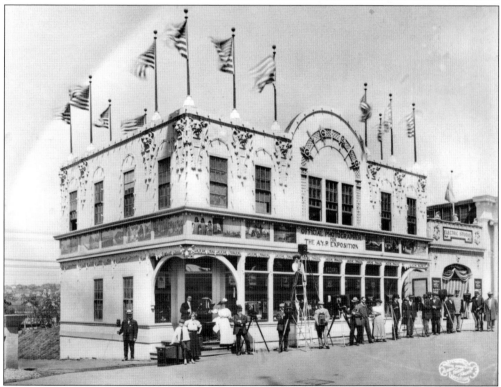

The Official Photographic Building, located on the Pay Streak, was the headquarters of Frank Nowell, the official AYPE photographer, as well as other professional photographers. Images that were developed in this building were the primary ones used in advertisements and newspaper articles. Amateur photographers were able to take an unlimited number of pictures of the exposition by purchasing a day pass. (Nowell x2820.)

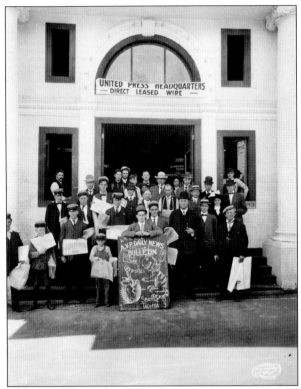

The official newspaper of the exposition was the *A.-Y.-P. Daily News*, and the staff and delivery boys pose here for a group portrait on the steps of the United Press Headquarters. Updates, events schedules, advertisements, and news were printed and distributed to visitors of the fair on a daily basis. (Nowell x2272.)

This view of the *A.-Y.-P. Daily News* printing office in the United Press Headquarters shows a working printing press with its operators and deliverymen on the right holding recently printed newspapers. The official AYPE newspaper building not only housed the printing press but also had linotype machines and other equipment necessary for printing a daily newspaper. (Nowell x2293.)

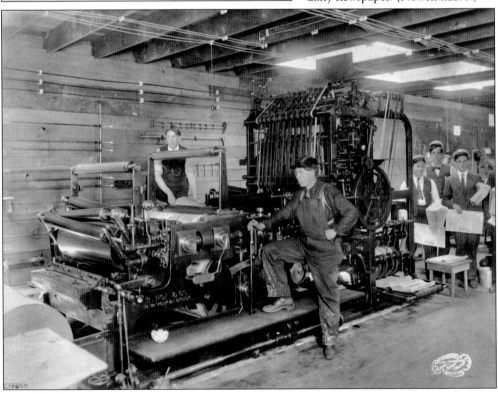

Products to be set up at the AYPE exhibits began with their delivery by rail and horse-drawn wagons. Here the Canadian exhibits are being unloaded from the Northern Pacific Railway car onto an official AYPE office cart preparing to be driven up the road to the Canada Building. In the background of the photograph is the smokestack of the Power House. (Nowell x537.)

The same type of official AYPE horse-drawn carts are seen delivering apples for cold storage to the Oregon Building as part of the installation of the first exhibits of the fair. These items had also been delivered by train to Seattle in preparation of displaying and feeding the anticipated crowds of fairgoers. (UW27554.)

The florist's office was a tiny log cabin surrounded by sweet flower gardens, and it blended in seamlessly with the landscape of the AYPE. This office housed gardeners and their supervisors, who were in charge of maintaining the elaborate sunken gardens south of the Court of Honor, as well as the entire manicured grounds of the fair. (Museum of History and Industry 1990.73.74.)

Nine

POSTCARDS, ADVERTISEMENTS, AND SOUVENIRS

Modern conveniences in advertising that are taken for granted today, like television and radio, did not exist in 1909. Promoting and advertising a World's Fair required utilizing all available resources to draw fairgoers. Without conventional means for evangelizing the fair, exposition promoters relied on publications and souvenirs to communicate the amusements and attractions to draw attendees.

Postcards played a critical role in advertising the AYPE. Each of the hundreds of postcard designs showcased the unique aspects of the fair such as the architecture, gardens, and amusements. Due to the lack of personal photographic equipment, fairgoers often preferred to purchase postcard souvenirs versus taking their own photographs. Fairgoers purchased these souvenirs as mementos to send to friends and family back home. Visitors could create personalized souvenirs by having whimsical photographs made into postcards. Local businesses often sponsored the customized souvenir booths and had their logos featured in the photographs.

In addition to postcards, businesses advertised through the *A.-Y.-P. Daily News* and the "Official Daily Program." The program offered guests a short schedule of events that they could attend during their visit to the fair, while the newspaper contained lengthy articles about the goings-on at the exposition as well as the city of Seattle. Hotels, restaurants, local businesses offering side trips, business schools, cruises to Honolulu, horses, tracts of land for sale, and an amusement park in Portland, Oregon, were some of the wares offered in these publications.

Novelty shops and concession stands sold souvenirs throughout the fairgrounds. Each of these items had a discriminating attribute that showed its unique relationship to the fair. Some of the more popular memorabilia included visitor maps, pendants, plates, saucers, lapel pins, metal badges, stamps, official medals, handkerchiefs, playing cards, cuff links, shaving kits, and purses. These now antique collectables are offered today for hundreds of dollars at auctions.

There was an air of friendly competition among the building sponsors. Each of the buildings pronounced its exhibits as being the best and as a way to advertise its sponsor. In the grander scheme, the AYPE was a giant advertisement for trade with Pacific Rim nations and to draw settlers into the Northwest and grow the small city of Seattle.

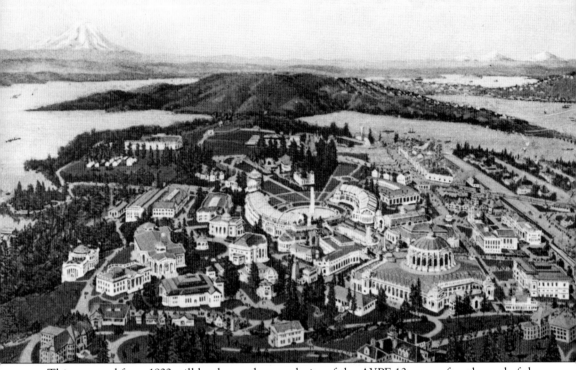

1922 — BIRDSEYE VIEW OF THE ALASKA–YUKON–PACIFIC EXPOSITION, SEATTLE, WASHINGTON.

This postcard from 1922 still banks on the popularity of the AYPE 13 years after the end of the fair. The map is a bird's-eye view illustration looking south toward Mount Rainier and showing most of the beautiful exposition buildings, Lake Union, Lake Washington, and some neighboring burrows. (UW23278.)

These individually numbered admission-ticket books allowed visitors into the front and south gates and the lake entrance of the exposition. Daily admission cost 50¢ and allowed guests unlimited access to the exposition buildings and their exhibits, gardens and grounds, and various visual oddities. Fairgoers had to pay additional charges for food, games, amusement rides, and other Pay Streak fun. (Nowell x1275.)

Mrs. Catherine A. Reed, who used heavy symbolism in her design, created the official AYPE flag. The field of blue on the left has five stars, which stand for the United States, Russia, France, England, and Spain—the five countries that first explored Alaska and the Yukon. The circle in the center represents Japan's flag, and the red, white, and blue symbolize the United States. (Nowell x45.)

Guests visiting the Pay Streak could purchase a personalized souvenir photograph like this portrait of four women in an airship. The dirigible was such a popular attraction that Lowry's on Madison Street created a life-sized advertisement for guests to pose in front of. These fun photographs were made into postcards that fairgoers could send to their friends back home. (Museum of History and Industry 2002.48.456.)

This souvenir photograph of a family of five in a parked automobile was also made into a postcard for the guests to send home. Automobiles were a fairly new form of transportation (the Model T Ford was only about one year old) and a huge source of fascination to fairgoers. (UW28095.)

"Caribou Bill" was the unofficial mascot of the AYPE and starred in his own advertisement for the exposition. The real "Bill" traveled by dogsled from Valdez, Alaska, to Seattle in time for the opening of the fair, as this ad shows him doing on the left. It also shows him meeting a lumberman who will be visiting the AYPE too. (UW24311.)

These souvenir and concession stands were typical shopping destinations for visitors searching for AYPE knickknacks. The huts dotted the center street of the Pay Streak and allowed guests to purchase souvenirs and snacks while they perused the wonders of the midway. The Japan Building can be seen in the background. (UW28071.)

This advertisement for the Hartford Carpet Company depicts an exact replica of the velvet carpet that was woven at the AYPE and placed on display by the Connecticut rug company. The ad encouraged guests to visit the weaving in person. The Native American depicted on the rug is stated as being "our first customer." (UW24314.)

This advertisement for the popular AYPE restaurant Nikko Café shows a rare interior view. This Japanese-themed restaurant served only American fare and was nearly always crowded with guests. Here is an inviting scene of fairgoers enjoying lunch surrounded by an attentive waitstaff. The ad beckons visitors to "meet me at the Nikko Café." (UW12019.)

This advertisement shows a portrait of Chief Seattle on an emblem floating over a drawing of Mount Rainier and Puget Sound. Chief Seattle, or "Sealth," was an iconic figure whose image drew visitors to the Pacific Northwest. He was the leader of the Suquamish and Duwamish Tribes and paved the way for friendly relations with white settlers in Seattle. He died in 1866. (UW28096.)

This advertisement for the AYPE depicts the Statue of Liberty hovering over Alaska holding ribbons connecting Alaska with the Pacific Northwest, the Orient, and beyond. Instead of a torch, she is holding a placard with "1909" shining from her hand. This ad was released in May 1907 and showed, in however vague terms, what sort of fair guests would look forward to. (UW18957.)

This advertisement depicts the famous Tlingit totem pole that resided in Pioneer Park Place (later Pioneer Square) in downtown Seattle, surrounded by pictures of the Seattle waterfront and a variety of AYPE buildings. The Tlingit totem pole was an icon for Seattle even though it came to the city by less than noble means; in 1899, a group of businessmen stole the pole from a local Native American tribe. (UW21287.)

This advertisement for Carnation Milk associates the goodness of its dairy products with the wide appeal of visiting the AYPE. Elbridge Amos Stuart founded the Pacific Coast Condensed Milk Company in 1899 in Kent, Washington. The company was later renamed and moved to Carnation, Washington, a city that was named for the company's dairy farms there. The brand was popular throughout the century. (UW23379.)

This advertisement brings Seattle and Alaska together by showing a Yukon man with a gold pan, a typical street in downtown Seattle showing modern storefronts and hotels, and the official seal of the AYPE featuring three women who represented the Pacific Northwest, Alaska, and the Orient. The front of the ad boasts that Seattle is the "Gateway to Alaska and the Orient." (UW22327.)

INDEX

ACROSS AMERICA, PEOPLE ARE DISCOVERING SOMETHING WONDERFUL. *THEIR HERITAGE.*

Arcadia Publishing is the leading local history publisher in the United States. With more than 5,000 titles in print and hundreds of new titles released every year, Arcadia has extensive specialized experience chronicling the history of communities and celebrating America's hidden stories, bringing to life the people, places, and events from the past. To discover the history of other communities across the nation, please visit:

www.arcadiapublishing.com

Customized search tools allow you to find regional history books about the town where you grew up, the cities where your friends and family live, the town where your parents met, or even that retirement spot you've been dreaming about.